New Art of
Willard Gayheart

CONTRIBUTIONS TO SOUTHERN APPALACHIAN STUDIES

New Art of Willard Gayheart

Willard Gayheart
and Donia S. Eley

Foreword by Grace Toney Edwards

CONTRIBUTIONS TO SOUTHERN APPALACHIAN STUDIES, 34

*To Joe
and the many
good memories of
the Blue Ridge*

Willard Gayheart
9/27/08

McFarland & Company, Inc., Publishers
Jefferson, North Carolina, and London

ALSO BY WILLARD GAYHEART AND DONIA S. ELEY

Willard Gayheart, Appalachian Artist
(McFarland, 2003)

LIBRARY OF CONGRESS CATALOGUING-IN-PUBLICATION DATA

New art of Willard Gayheart / Willard Gayheart and
Donia S. Eley ; foreword by Grace Toney Edwards.
pages cm. — (Contributions to Southern Appalachian studies ; 34)
Includes index.

ISBN 978–0–7864–6551–4
softcover : acid free paper ∞

1. Gayheart, Willard—Themes, motives.
2. Appalachian Region—In art.
I. Gayheart, Willard, author. II. Eley, Donia S., author.
III. Edwards, Grace Toney, writer of supplementary textual content.
IV. Gayheart, Willard. Drawings. Selections.
NC139.G225A4 2014 741.973—dc23 2013037651

BRITISH LIBRARY CATALOGUING DATA ARE AVAILABLE

On the cover: *Family Gathering at the Homeplace,* 1992;
inset detail from *Will Keys: A National Treasure,* 2003
(drawings by Willard Gayheart)

Manufactured in the United States of America

*McFarland & Company, Inc., Publishers
Box 611, Jefferson, North Carolina 28640
www.mcfarlandpub.com*

To
Hunter Eley

Michael Gayheart
Jill Freeman
Steven Gayheart

and

To the preservation of the culture
and history of Appalachia

TABLE OF CONTENTS

FOREWORD BY GRACE TONEY EDWARDS

Sometimes I feel as if I am in the midst of an incredible concert in my very own living room, with music coming from the likes of Doc Watson, Bill Monroe, Janette Carter, Wayne Henderson, and Willard Gayheart. That's because all of those talented musicians look down on me from their perches around my walls. Lined up to listen to the music along with me are farmers and quilters, scholars and auctioneers, college professors and students. All are the creations of the "Blueridge Master" himself, Willard Gayheart, pencil artist and musician extraordinaire.

Willard reaches into the valleys, coves, and hilltops of Appalachia, finding for his subjects the ordinary and the simple: a baptizing in the river, a father and his family feeding his horse, a basket maker weaving her splits into a usable vessel, old friends sitting in front of a country store, the trilling voice of the auctioneer, the rhythms of a fiddle, a banjo, a mandolin, a guitar. The viewer finds herself transported down memory lane or onto a path she wishes she could walk. The images in the drawings are alive, vibrant, and joyful. The faces of the subjects carry smiles, contented peace, or directed concentration. Often the body language and the facial expression are subdued just enough to suggest the Appalachian native's natural reserve. Willard's art leaves the viewer feeling satisfied, even if at times a little melancholy.

Early in his career Willard called his drawings "Nostalgic Glimpses of the Appalachians." Today he shows us contemporary Appalachia as well, especially as it lives in the music and other folk traditions that still thrive in the region. Particularly noticeable in his art is a reverence for

teaching and learning. Drawing after drawing depicts a learner at the feet of a master, as in the young guitarist who sits next to Doc Watson or the child who plants bulbs with her grandfather. Children permeate. the works, illustrating his recurring theme of handing traditions on from one generation to the next. Group dynamics are also important in his art, portraying the sharing of talents, the sharing of work, the sharing of friendship and love.

Years ago an eager learner and lover of the arts began to take note of Willard Gayheart's talents. She and her husband purchased numerous Gayheart prints for their own collection. When she enrolled as a student in an Appalachia in the Media class at Radford University, she had opportunity to capitalize on her knowledge and love of his work. She proposed a class project based on his drawings of Appalachian people and landscapes. Her intent was to show how pencil art becomes yet another form of media depiction of Appalachia.

Too good to stop at the classroom door, the project took on a life of its own. With a bit of prodding, the scholar developed that project into a book entitled *Willard Gayheart, Appalachian Artist,* published in 2003. I speak, of course, of Donia S. Eley, co-author of the first volume about Willard and his pencil magic, and now of a much needed second volume. Donia's energy and excitement have never waned over the dozen or more years this work has been ongoing. She has ferreted out drawings long forgotten by the artist himself; she has traveled far in her search for the art; she has engineered the scanning and copying of more than eighty drawings for the book; and she has interviewed many to discover the sentiments attached to the art by those who own it. Indefatigable in her passion for the work, Donia Eley has been the consummate researcher and writer for this enterprise.

And she is a perfect complement to Willard Gayheart in the working partnership they have forged. Willard is a soft-spoken humble person who puts pencil to paper or fingers to guitar and produces magic. Donia is the extrovert who loves the magic and wants to share it in a way that will make it accessible to many others. She has become Willard's most ardent advocate, his record-keeper, his historian and, to some extent, his biographer. Her work catalogs and preserves his work and his life in a manner that goes beyond both the art and the man. Willard, the artist, and Donia, the author, blend harmoniously, and the result is the beautiful melody that is this book.

I am personally grateful to both for the energy, effort, excitement, talent, and love they have poured into the book's making. And I am deeply honored to have been invited to write these words at the outset of what promises to be a delightful journey into Willard Gayheart's and Donia Eley's Appalachia.

Grace Toney Edwards is a professor emeritus of English and Appalachian studies at Radford University, where she was the founding director of the Appalachian Regional Studies Center and chair of the interdisciplinary Appalachian Studies Program. She served as senior editor of A Handbook to Appalachia *and co-editor of the literature section of the* Encyclopedia of Appalachia *(both 2006). She has published more than 100 book chapters, articles, essays and reviews.*

PREFACE AND ACKNOWLEDGMENTS BY DONIA S. ELEY

This is the second book presenting the art of Willard Gayheart, a pencil artist from Woodlawn, Virginia, who has gained widespread acclaim for his ability to take a piece of graphite and create a beautiful drawing to commemorate an event, immortalize a public figure, depict someone's family member, portray a famous (or not-so-famous) musician, or capture a scene from a culture that might otherwise become only a nostalgic memory.

This volume attempts to capture as many of Gayheart's works as possible. The drawings here include works he has completed since the first book in 2003, but also drawings done many years ago that were forgotten, unavailable, or simply overlooked in the first book. No drawings are repeated from the original book.

Record keeping does not hold the same interest for Willard as drawing, so there is no formal list or history of his work in existence. These two books are effectively the only records, and despite our best attempts, we have undoubtedly missed some works that deserve attention.

Collecting these drawings has been a voyage of discovery. Finding one drawing often led to someone remembering having seen or heard about another, and thus on and on went the discoveries. Some were as close and attainable as a drawing of a family gathered around a table in Hiwassee, Virginia. Others were elusive, like the drawing of a mountain scene commissioned by a Frenchman. Pencil drawings kept turning up. We got hold of most of them, but not all, particularly not the one in France.

What a treasure hunt. Out of homes and offices and universities across the country came wonderful black-and-white drawings and one beautiful color portrait. Often Willard would bend forward, arms folded across his chest, chin resting in one hand, and chuckle when presented with a work he'd completely forgotten about. People who know him know that stance.

Some of these drawings were commissioned works, some were done as fundraisers for various worthy causes, and many were drawn for the artist's own enjoyment. The search has been a time-consuming joy, filled with people delighted to share and discuss their prized artworks. The longer I looked, the more people I found who love Willard Gayheart, his art, and his music.

We have made every effort to set names down correctly, and we regret any errors that may have eluded us. A long list of people helped to pull this project together—too long a list, unfortunately, to name them all here.

I start with Willard himself. He has patiently answered my many questions; days, nights, and weekends he has taken my calls and provided guidance about an obscure or forgotten drawing. Jogging his memory and watching the smile of surprise each time a forgotten drawing came to light have been priceless experiences. He also smiled graciously each time I put a camera in his face to record an event or conversation.

Without the agreement of many owners of Willard's work to loan their drawings for long periods of time and to permit their reproduction, and without their willingness to answer my questions about the works, this book would not exist. I am grateful to each of you for helping to preserve Willard's contribution to Appalachian culture.

Others who have assisted, some with specific purpose and others unknowingly through their support and encouragement, include: Patsy and Frank Gilbert; Hunter, Lael, Bowden and Baird Eley; Scott and Jill Freeman; John Nemeth and Grace Edwards; Julie Williams; Kathy Murphy; Paul Haaf; Debbie Gardner; Lisa Noell; Margaret Cox; Jan Carroll; Kathy Jordan; Cary Sutherland; and Steve Kirkner.

We are indebted to Ricky Cox, who lives in Floyd County and teaches at Radford University, for carefully scanning each of the 87 drawings to exacting standards and for his ongoing encouragement in this endeavor.

James Harman helpfully took the huge digital file of art and writing and made it all work for me. Thank you, James.

Debbie Brown, thank you for being the first person to read the finished manuscript.

INTRODUCTION

Family

Willard, age 81, continues to live in Woodlawn, Virginia. Pat, his wife of 52 years, died in April 2012.

Living nearby in Woodlawn are Willard's children, his son Steven and wife Kathy, and their daughter, Sarah. Willard's daughter Jill and her husband, Scott Freeman, and granddaughter Dori Freeman also live in Woodlawn. Another son, Michael and his wife, Leesa, and stepson Cole Morris live in Grayson County, Virginia.

Willard's mother, Dora Gayheart, died in 2009 at the age of 98. He has a brother, Ira Coleman Gayheart, who lives in Jonesville, Kentucky.

Front Porch Gallery

Since the release of the first book about Willard's work in 2003, much has stayed the same yet much has changed. He continues to sell his art from the Front Porch Gallery in Woodlawn, Virginia, just off Interstate 77 in Carroll County between Hillsville and Galax. He still seems constantly in motion, this 81-year-old prolific artist, as he moves quickly through his busy days minding the gallery, seeing to his framing business, performing with one group of musicians or another all over the region, and completing one drawing after another, always in demand.

Willard and his daughter Jill Freeman continue with their framing

business, but now his son-in-law, Scott Freeman, also uses the store to teach music there several afternoons a week. Scott teaches guitar, mandolin, fiddle, and bass to between 50 and 60 students a week.

Also for sale in the gallery are a number of CDs. Willard's musician granddaughter, Dori Freeman, sells her CDs there, Scott has CDs for sale, and there are about five different CDs that include all three with son Michael sometimes joining the group.

Fiddle and Plow

A visitor to the gallery these days will find a new addition, rows of folding chairs lined up facing an area set aside in the gallery for musicians. This is for a weekly event known in the region as Fiddle and Plow, where music lovers come every Friday night for a 7 P.M. show. Thirty chairs are set up with cut-to-fit squares of foam providing cushioned seats for the audience at the weekly performances. Twenty additional chairs and cushions are stowed close at hand for quick access on any Friday night the crowd grows.

Begun in May 2010 by Willard and son-in-law Scott, this music venue has become a popular gathering place. In September 2012 it was designated as an official music venue on the Crooked Road. Featured performers have included Wayne Henderson, award-winning musician and instrument maker from Rugby, Virginia; the VW Boys with Tim White, coordinator and host of *Song of the Mountains*, filmed at the Lincoln Theater in Marion, Virginia; Butch Robbins, noted banjo picker; Buddy Pendleton, a world-class fiddler from Woolwine, Virginia; Jack Hinshelwood, musician and executive director of the Crooked Road; Steve Lewis, national champion banjo picker and guitarist; and Johnny and Jeanette Williams, bluegrass musicians from Danville, Virginia. These musicians are but a few of those who have entertained visitors over the past few years.

Gayhearts in the Region

Aside from adorning the walls of homes across the region and beyond, Willard Gayheart's drawings hang in offices, restaurants, galleries, and

stores. His drawings illustrate the book *Mountain Summer* by William H. Mashburn as well as various record album covers.

A recent walk through the little town of Floyd, Virginia, turned up a selection of Willard's work in the New Mountain Mercantile, a shop on South Locust Street that carries local art, jewelry, gift items and numbered prints by Willard Gayheart. The owners met Willard 21 years ago at the Old Fiddlers' Convention in Galax where they were vendors. They have enjoyed good response to his art over the years.

Willard has many local fans, one of whom is Erynn Marshall, music director of the nearby Blue Ridge Music Center. She said:

I met Willard Gayheart in 2009, shortly after I started working at the Blue Ridge Music Center on the Blue Ridge Parkway near Galax. Even though I had just moved to Virginia from Canada, I had seen Willard's artwork at various music festivals or friends' homes across the country in my earlier travels. I really looked forward to meeting the man with that extraordinary ability to capture the real essence of southern mountain people on the page— equipped only with a pencil!

Willard had heard about me, too—a life-long fiddler from Canada coming to help manage the concert series at the center. It turns out he wanted to meet me, too.

Since we have Mid-Day Mountain Music daily at the Music Center I expected to see Willard on the first Tuesday we were open because that is his regular slot to perform with equally renowned musician, Bobby Patterson. I walked into the breezeway and when I saw Willard for the first time and he saw me, there were two of the biggest smiles on our faces. It was like reuniting with an old friend. We introduced ourselves, chatted up a storm, and I'd like to say we've been mighty fine friends ever since!

As far as Willard's artwork goes, I'd like to say his deft pencil strokes render a lot more than the mere images of Appalachian folks. You get a sense of how these people lived their lives, what they were like, or cared about. From the calloused hands of a man who'd farmed for decades to the gnarled knuckles of an aged fiddler leaning back in his rocking chair, grinning while he plays a favorite tune, you get a strong impression of these people's natures and experience on life's road. You can see the loving light in the eyes of a grandparent helping a young granddaughter dig in the garden, or spy the sweat on the brow of an apron-clad woman digging potatoes. If Willard draws an apple you can almost smell it! His title lets you know about a heritage apple called the "Virginia Beauty." He just captures so much more than graphite on paper ... there's a little bright spirit or soul of the people he knew present in the picture.

Speaking of spirits, Willard often draws those, too ... local people who have passed on like Merle Watson or Estill Ball—faintly seen hovering above those still living or the depicted memory of a musician, living or gone, who has influenced others to play like Jean Ritchie or Kilby Snow. In these instances, through Willard's art, you get sense of how meaningful the passing on of cultural traditions is to rural families in the Blue Ridge.

Willard is a master artist, accomplished musician, songwriter, shopkeeper framemaker, and presents local community concerts at his gallery in Wood-lawn, Virginia, most Friday nights. These are among the many reasons he is so beloved in the community. He is the kindest, most genuine person I have met in a long time and I have an inkling that might be one of the great secrets to his success and art.

Judy Ison, director of the Fine Arts Center for the New River Valley in Pulaski, Virginia, remarked, "Willard Gayheart's art has been a part of the Fine Arts Center's gift shop here for more than 25 years. His orig-inal works and prints are becoming more and more sought after since the publication of the first book about his art. It has been my pleasure to know Mr. Gayheart as an artist and musician, and his contribution to the arts is phenomenal."

Grace Toney Edwards, who has an extensive art collection at home and in her office at Radford University, and wrote the foreword to this book, had this to say about exhibiting his work in both places:

I first met Willard Gayheart in the 1980s through his association with the Appalkids, a group of youngsters from Pulaski County High School whose mission was to preserve and honor traditional story and song in their mountain culture through performance. Led by creative English teacher Rebecca Han-cock, the Appalkids invited Mr. Gayheart to display his art work and to perform music with them at a presentation at PCHS. I had the great good fortune to be included in that event. Mr. Gayheart's humble modesty regarding his talents immediately won my heart. Shortly thereafter, the Appalachian Events Com-mittee at Radford University invited him to demonstrate his pencil artistry at the annual Appalachian Folk Arts Festival. His drawing entitled *A Turn to the Light* spoke to me in a way that meant I must have it! I bought it and hung it in my RU office, where I was inspired every day by the elderly gentleman sitting on his porch reading while a stack of light-filled books rested on the table by his side. The print drew frequent praise from students and other vis-itors who seemed to profit from the message in the art just as I did. Today, thanks to my husband who merged his art collection with mine some years ago, I have yet another copy of that same print hanging in my home where,

among other Gayheart treasures, it continues to hold a place of prominence—but most especially in my heart.

Willard's art turns up in unexpected places, often with a story. A college student from the Galax area remembered one of his drawings hanging in the office of her advisor at James Madison University in Harrisonburg, Virginia.

That advisor, Danielle Torisky, associate professor in health sciences at JMU, kindly explained how the drawing came to be there and what it means to her. The drawing is *A Pickin' Place* and was completed in 1990. It features Willard's daughter Jill playing the banjo on a porch.

Danielle explained that she spotted the drawing at Willard's booth at the Galax Old Fiddlers' Convention in 1990: "I caught sight of this drawing and loved it." She asked for his business card and later contacted the Front Porch Gallery to see about acquiring a print. Jill Gayheart Freeman, the subject of the drawing, answered the phone, and Danielle reported it was wonderful to actually speak with the subject of the work.

When asked if this work has special meaning for her, Danielle explained that she competed several years at Galax in folk song competition, and that she is a keyboard musician who loves old time and bluegrass music, especially the banjo: "I love the sound of it!" Danielle also learned mountain clogging in the 1980s with banjo and other old time instrument bands. In recent years she has been fascinated with learning more of the history of the banjo back to its origins in Africa.

Danielle says this drawing hanging in her office reminds her of the big part of her that is musical and that she still loves the Appalachian culture from living in Southwest Virginia before moving to the Shenandoah Valley. She still holds on to the possibility of learning to play the banjo someday, or playing keyboard with an old time band.

The Crooked Road to Art Collection

Following publication of the first book in 2003 we realized that though that book represented 78 drawings spanning the years 1979 to 2002, many drawings remained unpublished. Readers found that a work that they had commissioned or purchased did not make it into the book and often

expressed regret. Being able to contact these art appreciators about a second opportunity has been very gratifying.

The attempt to put this book together, to gather all of Willard Gayheart's art and bring it to one place for the enjoyment of old and new fans, has been an amazing journey. The authors have driven parts of the Crooked Road, and as its name implies, it is filled with unexpected twists and turns. Such has been this journey.

For two years, over and over, it seemed as if there could not possibly be another Gayheart that the authors had missed. Surely we'd found them all. But they kept surfacing, and we kept adding more drawings until we had collected all that appear on these pages. If more still remain, we look forward to learning about them.

THE ART OF
WILLARD GAYHEART

*Text in italics comes from interviews
with Willard Gayheart and others.*

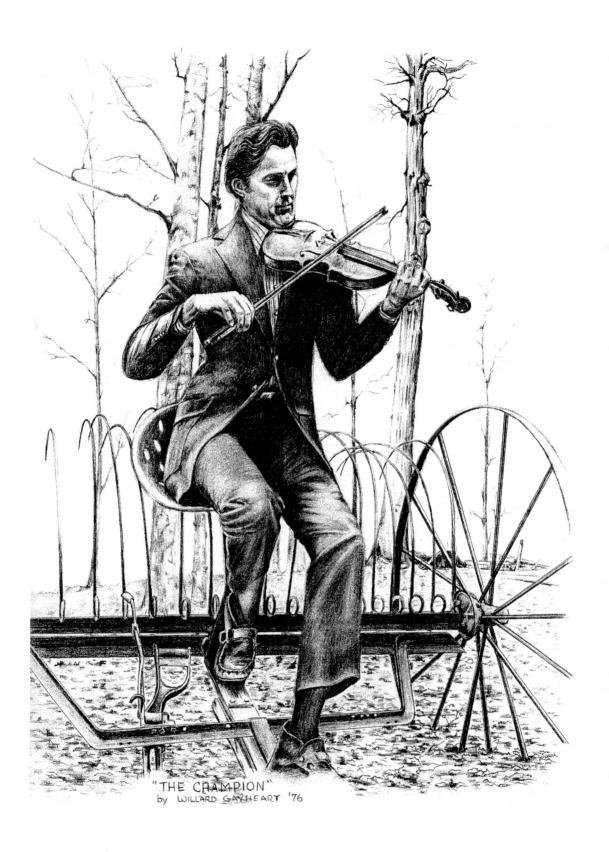

"THE CHAMPION"
by WILLARD GAYHEART '76

The Champion
1976

From time to time back in the 1970s Willard would do a drawing and place it in the window of a store he ran in Galax, Virginia, in hopes of a sale. Such was the case with this drawing.

The artwork was bought by Clinton and Naomi Conner on one of their visits to Galax. Naomi recalls that they saw *The Champion* in Willard's store window. Naomi knew the artist and Clinton knew the subject. For the couple it must have seemed like "old home week" and for Willard it was the beginning of many years of art that continues to today.

The Champion features Buddy Pendleton, a well-known fiddler from Woolwine, Virginia, and according to Willard, Buddy has become a legend around the Blue Ridge. He won a World Championship at the Union Grove Fiddlers' Convention in Union Grove, North Carolina, several times, won first place at the Galax Old Fiddlers' Convention more than once, and played with Bill Monroe and a long list of other notable musicians.

Home, though, was Patrick County, Virginia, where Buddy served for many years as a rural mail carrier.

Naomi explained that Buddy grew up in an area of Patrick County near Clinton's home, and that Naomi's father and Willard were friends. Her father introduced Naomi and Willard because they both attended Berea College.

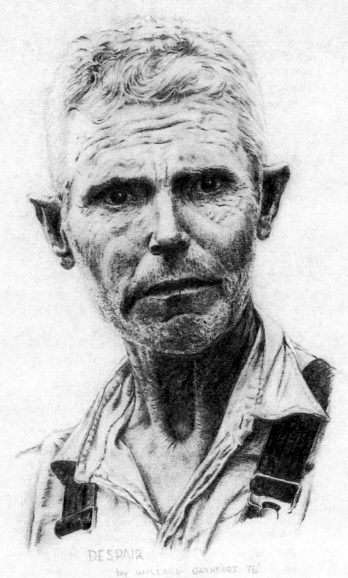

DESPAIR
by WILLARD GAYHEART 76

Despair
1976

This drawing is Willard's portrayal of how a man's face might have expressed his circumstances during the years of the Great Depression, 1929–1939. Willard entered the work in a contest in 1976 at Wytheville Community College, but doesn't recall the outcome of the competition.

Little else is known about the drawing except that the original is owned by David and Elizabeth Williams, long-time friends of Willard's family, and fellow church members.

According to the Williamses, "The drawing conveys all the emotions of a man caught in the despair of such a time in history."

Jill & Tiger
1976

Jill Gayheart Freeman remembers being "11 years old and aggravated" at her father in 1976 when he had her pose with the kitten. Now the drawing hangs in her home in Woodlawn.

Willard recalled that he usually entered an annual art contest at Wytheville Community College and generally won ribbons, but he doesn't remember the outcome of this entry. He said this was done before he started adding backgrounds when he was using a lot of charcoal and experimenting with pastels. It was around 1979 when he did the first drawing with a background. He likens it to painting a picture with graphite, doing the whole scene.

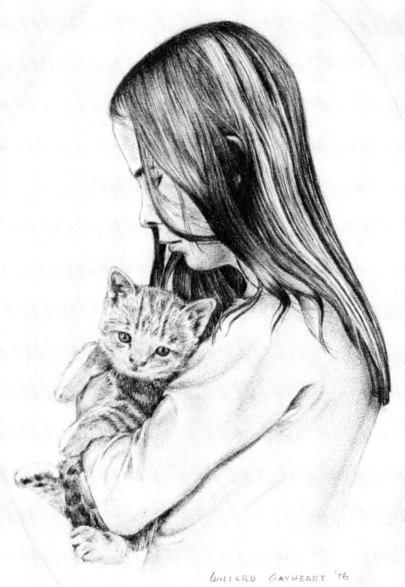

WILLARD GAYHEART '76

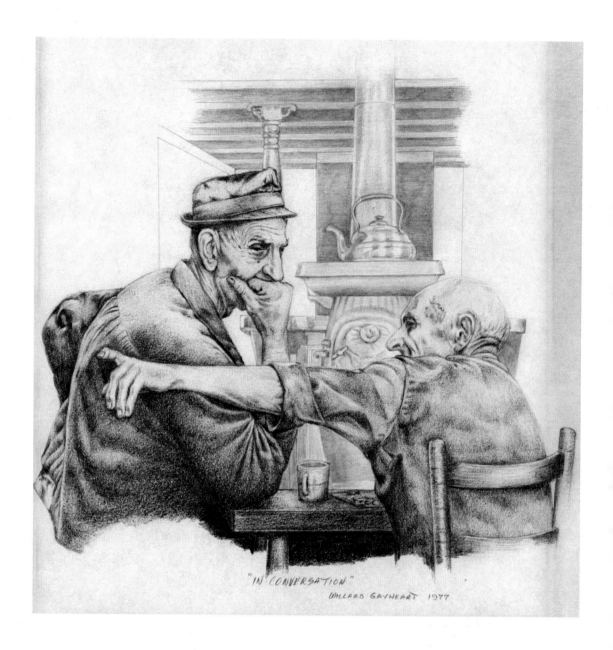

"IN CONVERSATION"
WILLARD GAYHEART 1977

In Conversation
1977

Willard doesn't recall exactly where he came up with the idea for this work other than seeing a picture that caused him to want to draw the scene. He did, and thinks it earned a ribbon from the juried show he entered at Wytheville Community College in 1977 or 1978.

The original was purchased by the college for the president's office and it hangs there today for the enjoyment of Dr. Charlie White, the current president, and visitors to his office.

Willard says he's glad Charlie White enjoys this drawing: it's especially nice since Dr. White has long been instrumental in supporting and promoting old-time and bluegrass music. In 1991 he began the New River Community College Fiddle and Banjo Club in Dublin, Virginia, and in 2006 he helped establish the Bluegrass and Old-time Jamboree at Wytheville Community College. Both programs are going strong and a calendar of events can be found on the college website.

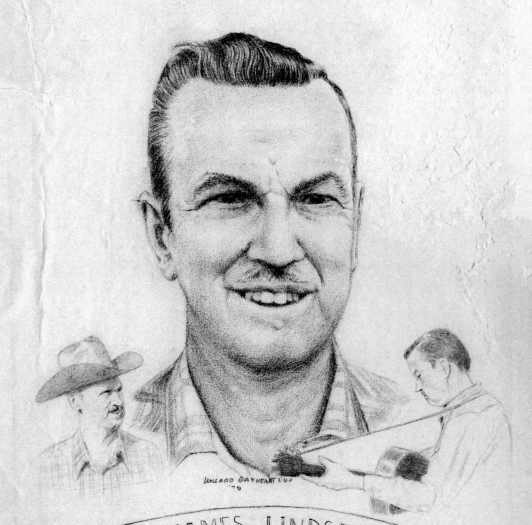

JAMES LINDSEY

MUSICIAN, SPORTSMAN, PHOTOGRAPHER, SALESMAN

"HE LIVES EVERY DAY TO ITS FULLEST"

James Lindsey
1979

James Lindsey's bluegrass band, the Mountain Ramblers, was the first band Willard played in, and he has many fond memories of James. Willard recalled that he met James in 1962, the year he and wife Pat moved to Galax where Willard was to manage a department store. James worked for a radio station in Hillsville and would come into the department store to sell radio ads to Willard.

The topic of music led them to jam together and after a year or so Willard joined the Mountain Ramblers, an opportunity for which he credits James. This drawing was a gift to James, commissioned by his wife. Willard described James as a musician, sportsman, photographer, salesman, and "he lived every day to its fullest."

"He was an excellent band leader, one who knew how to organize and find good musicians, book shows, and a leader who was diligent about the ways to keep a good group together," said Willard. "James was a determined musician."

The Mountain Ramblers won the Galax Old Fiddlers' Convention and other contests several times. Willard remarked, "No one loved bluegrass music more than James Lindsey."

Larry Lindsey, the toddler son of James when Willard first knew him, grew up to play with the Ramblers in his teen years and has since had Willard do several drawings of his family members. Those drawings, which are featured in this book, include: *James Lindsey, Blueridge Masters*; *A Mother's Touch*; and *The Homecoming*.

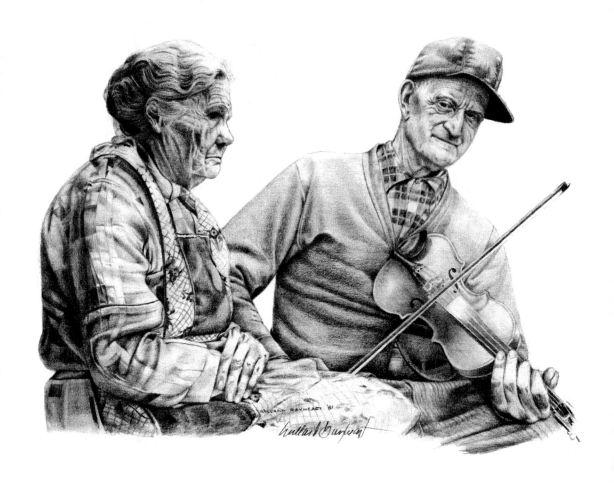

Jessie "Edgar" and Fannie King Higgins
1981

In 1981, Dot Higgins of the Galax area and the daughter-in-law of Edgar and Fannie Higgins commissioned this drawing of the Higginses as a gift for her son, Ronnie, a Virginia Tech graduate residing in Houston, Texas. Ronnie has since returned to make his home in Woodlawn, Virginia.

The relationship between Willard and the Higgins family goes back to the time Willard worked for Arnold's Store, about 1981. The Gayheart and Higgins families also attended the same church, Mt. Olivet Methodist Church, and they remain members of the congregation today.

Only several prints of this drawing are in existence, and they are owned by Higgins family members.

Enoch Rutherford
1982

Enoch Rutherford, a well-known fiddler, lived in Grayson County, Virginia, until his death in 2004. His recordings of traditional music are still available for purchase at the Heritage Shoppe next door to Willard's Front Porch Gallery.

Willard created this drawing for good friend Edwin Lacy, a Presbyterian minister and banjo player from Bristol, Virginia, who, in turn, calls Willard his hero. For Edwin the drawing is very special since he thought of Enoch as "an absolute character, so funny and full of life."

According to Edwin, Enoch's masterful ability as a banjo picker was so often overlooked because of the man's comedic presence on stage. After hearing him play a performance of "beautiful banjo music," Edwin was backstage and asked Enoch why he didn't play like that all the time. His response: "People don't want to hear that music, they want to be entertained."

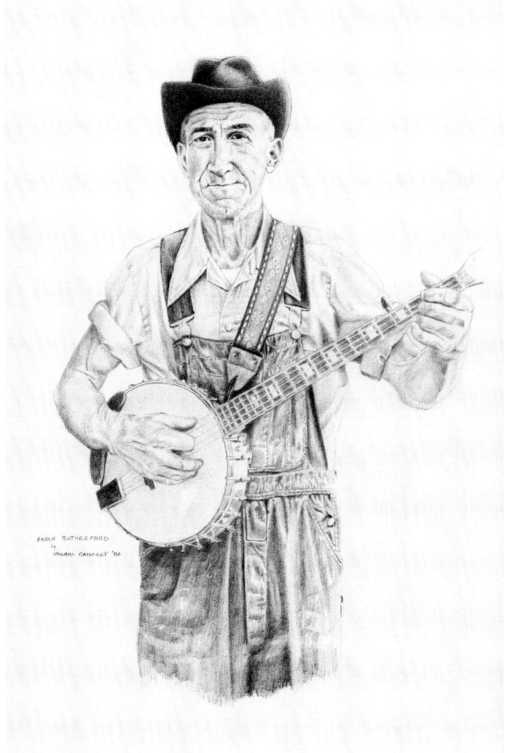

ENOCH RUTHERFORD
by
WILLARD GAYHEART '82

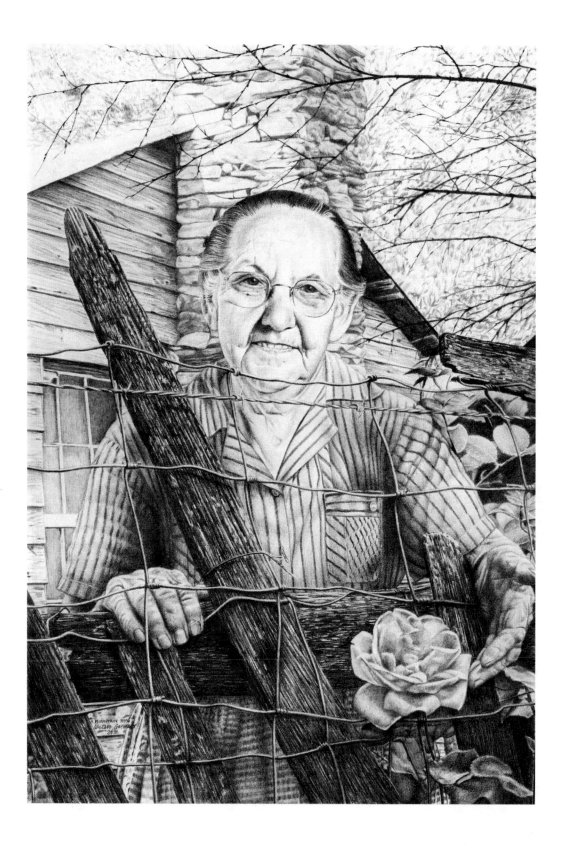

Mountain Rose
1984

Willard's grandparents John and Rosa Grigsby Gayheart lived in Knott County, Kentucky, in the Cordia community.

Before she died and long after retirement age my grandmother cooked at the school lunch room and the kids loved her. She was close to 80 when she died, a remarkable person, a hard worker, and I have lots of fond memories of her. When I was a boy, she would teach us to work in the fields. We weren't big enough to hoe the corn so she would have us thin it and make sure there were two stalks to the hill. We didn't like it because it was work so she would play games with us to get us to work and pay us a nickel or something.

She was from the old school and did everything, made soap, canned and dried foods, made molasses, sewed, just everything. She was a widow most of her life because my grandfather died at 52 and she was somewhat younger and had a baby when he died. She raised 8 children alone. At age 60 she started work at the school and worked until she was no longer able, in her 70s.

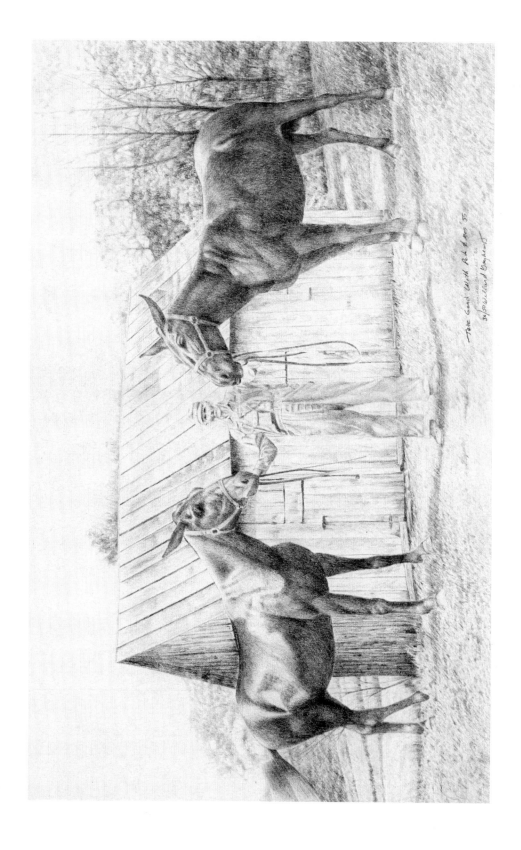

Two Good Will Raised Eggs 55
3/50 Richard Creighton

Tate Goad
1984

Alice Watkins commissioned Willard to create this drawing of her grandfather Tate Goad of Burks Fork Creek, in Dugspur, Virginia, where he was born in 1886 and lived all his life. She recalled her grandfather asking her to take the photograph when she was about 15 years old.

Tate and his wife, Lizzie, supported their family by raising pigs, sheep, and produce, and selling eggs, chickens, and milk. In addition, Lizzie had a small mill where she ground corn into meal for neighbors, taking a portion for pay to help feed the children. She also ran a small country store at times and worked the Burks Fork Switchboard, which provided phone service for the area.

Featured in this drawing with Tate is a pair of mules, Pete and Meg, and Alice remembered, "They were his pride and joy." He never owned or drove a car, instead depending on a buckboard wagon to transport his family or the goods his family sold.

Artist in the Park
Charlotte Lou Atkins
Check, Virginia
1985

Charlotte Atkins, who is the subject of *Artist in the Park*, got to know Willard and his art during the mid 1980s at the YMCA Craft Fairs at Virginia Tech in Blacksburg, Virginia. The annual autumn event has been going on for over 40 years. Willard displayed and sold his art from a booth at the fair for a number of years, and Charlotte drew 30-minute charcoal portraits of fairgoers.

Willard said, "Charlotte always wore a big black signature hat." He recalled she also wore vintage clothing, long skirts in autumn, but always her big black hat. Even in summer she wore the hat, but with cooler clothing as illustrated in the drawing. Charlotte confirmed Willard's observations.

This drawing resulted from a photograph taken at another festival the two participated in, Hungry Mother Days at Hungry Mother State Park in Smyth County near Marion, Virginia. Charlotte gave the original to her mother who "displayed it with pride" in her home until her death. Then it went to hang in Charlotte's home studio near Floyd, Virginia.

Charlotte continues her art career throughout Floyd County where she still draws people and has done commission work for the Town of Floyd, the U.S. Department of the Interior for Mabry Mill tourism on the Blue Ridge Parkway, and two days a week can be found working at Floyd's Jessie Peterman Memorial Library.

Charlotte says, "I was delighted with his drawing" and that Willard's drawing "captured what I enjoyed about drawing people around people."

Most of the 100 prints Willard made have been sold.

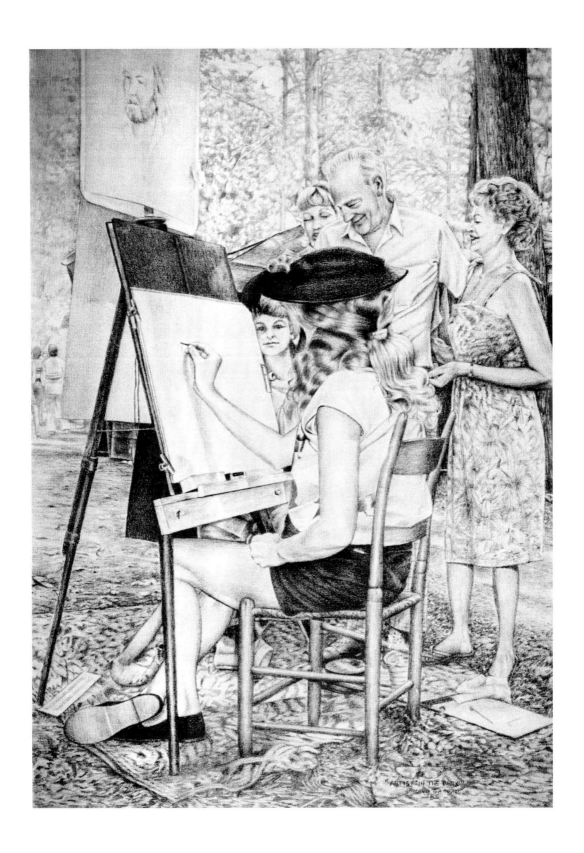

"ARTIST IN THE PARK"

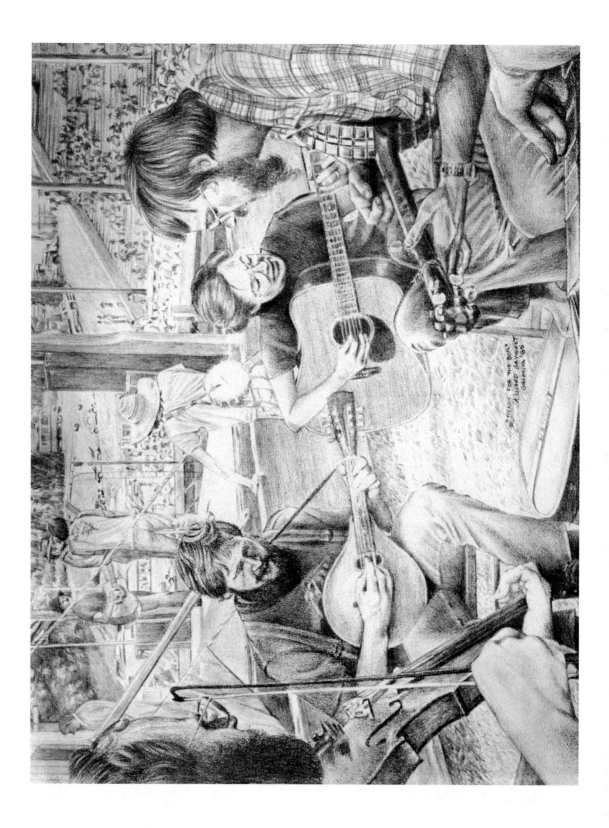

Getting Ready for the 50th
1985

In 1985 Willard wanted to do something special to commemorate the 50th anniversary of the Galax Old Fiddlers' Convention. He had taken some photographs of a couple playing in one of the many jam sessions around Felts Park, so he used those photographs and as Willard often does, he filled in the background with a scene he felt represented what was going on at the convention that day.

Willard said the couple came for several years from Alabama, but then he didn't see them any longer. Fifty prints were made and sold to benefit the Chamber of Commerce, and Willard gave one to the Alabama couple. He doesn't know where the original might have gone.

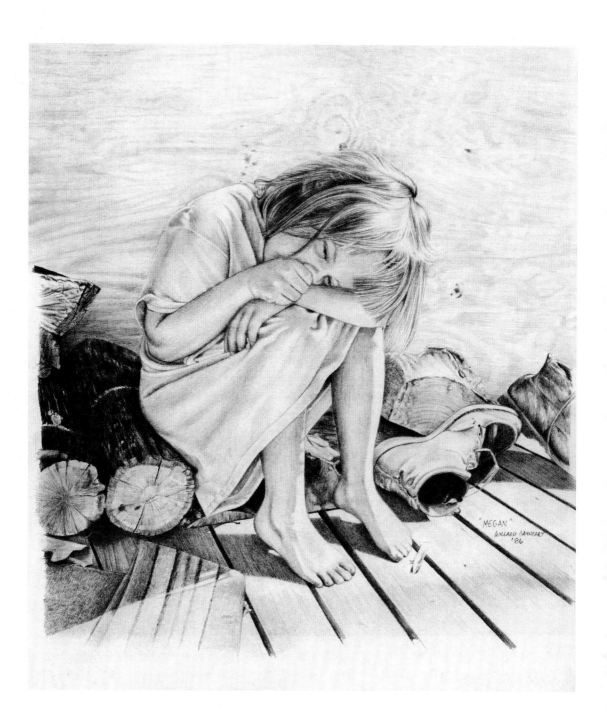

Megan
1986

On a warm spring morning in about 1979, Jim Padgett of Galax, Virginia, was out getting wood when his daughter appeared on the porch, sat on the logs in the sunlight and put her thumb in her mouth. Jim grabbed his camera and took a photograph.

Clad in her father's oversized T-shirt, Megan is sitting by the old work shoes of a grandfather who adored her. Grandfather and granddaughter were very close and shared that relationship until his sudden death of a heart attack the day before his 72nd birthday.

Megan continues to live in Galax, has two sons, and Jim Padgett is about to become a great-grandfather. He treasures this drawing, saying, "Willard Gayheart is a great talent."

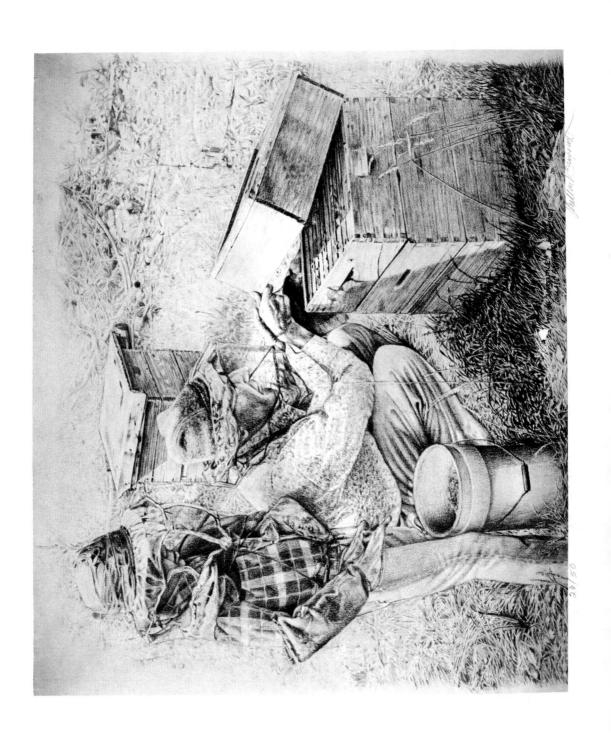

Young Apprentice
1987

Young Michael Bowers is helping his maternal great-grandfather, Worth Edwards, with his bees in this piece, which was done by Willard for Emmett and Sandra Bowers of Galax.

The story told about Grandfather Edwards is that he was known in the Grayson County, Virginia, and Sparta, North Carolina, area as "the bee man" who left the area before the Depression and headed north to find work. He found it at Ford Motor Company in Michigan and worked there until Henry Ford, also a beekeeper, learned of Worth's abilities with bees and hired him to work in security at the Ford Museum and help Ford with his bees during his off hours.

The original of this drawing hangs in the Bowers home.

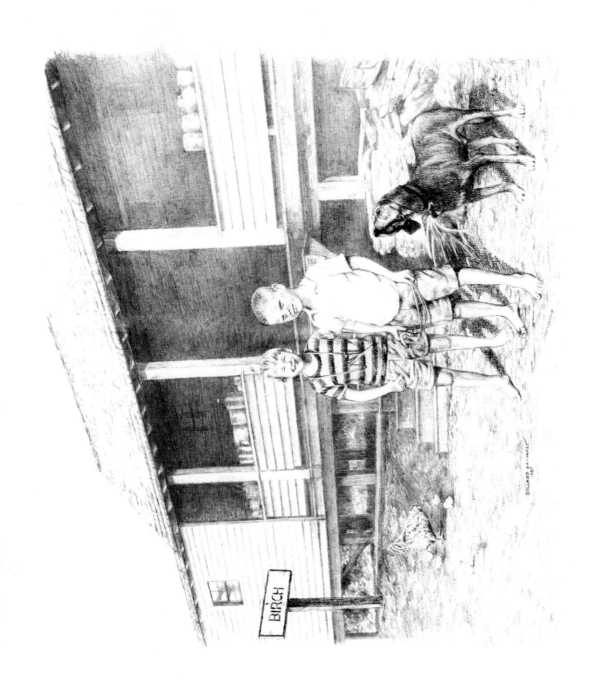

Birch
1988

Walking through a restaurant in Galax, Virginia, in the 1980s Bill Mashburn was so startled by a framed pencil drawing on the wall that he recalled asking, "Who drew that picture of me?" He chuckled at the memory of that moment when he first spotted a Gayheart drawing, one that reminded him of himself and resurrected memories of growing up in the mountains.

That drawing, entitled *Preparing for the Hunt*, is found on page 36 of *Willard Gayheart, Appalachian Artist*, published in 2003. Bill said he could have been the boy sitting on the stump with the slingshot dangling from his jacket pocket and holding the head of his dog, Buck. It is a perfect example of why people love Willard Gayheart's work. Whether a scene of a child on a beach, a woman at a spinning wheel, men weaving baskets, a man behind a plow, or a boy with a slingshot, we are reminded of someone we have known, a moment in life, or an experience. His themes are universal. In the case of *Preparing for the Hunt* Willard drew from photographs he had of a coonhound called Old Drum and the dog is featured in several of his drawings. The boy is his own son, Michael. But it could have been Bill Mashburn.

Birch does, in fact, feature Bill Mashburn. Birch was Bill's homeplace in Cherokee County, North Carolina. Bill, standing on the right near his dog, is holding his slingshot and about to go fishing with his friend Rob. The boys had cut a fishing pole, dug worms in Granny's garden, and planned to catch horny heads, a fish with bumps on their heads, to be fried by Bill's mother.

The building in the background was Bill's grandmother's home that also served as the post office and unofficial community center. There was also a water-powered sawmill and a place to grind corn on the property. His grandmother was a licensed midwife, his grandfather a postman and shoemaker.

Bill Mashburn and Willard Gayheart met and "hit it off," according to Bill. When Bill was writing his memoir, he asked Willard to illustrate it. Willard agreed, and his drawings can be found throughout *Mountain Summer*, which was published in 1988 by Pocahontas Press in Blacksburg, Virginia.

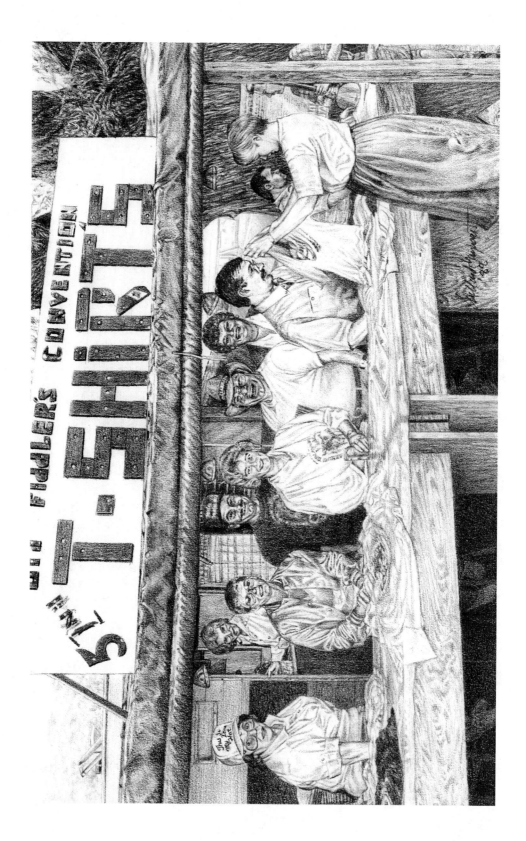

T-Shirt Stand
1988

For a number of years, perhaps ten or fifteen, Willard helped design the official T-shirt for the Galax Old Fiddlers' Convention held annually in August at Felts Park. Kyle Moretz was the only person allowed to sell a T-shirt inside the park. He would come up with an idea, and Willard would take it from there and create the drawing for the shirt.

Willard said it was a bartering situation. He did the drawing and in return received T-shirts for his family members.

This particular drawing was actually done as a gift for Kyle, commissioned by his wife Sandra. Kyle, now deceased, is featured on the right showing a shirt to a potential customer.

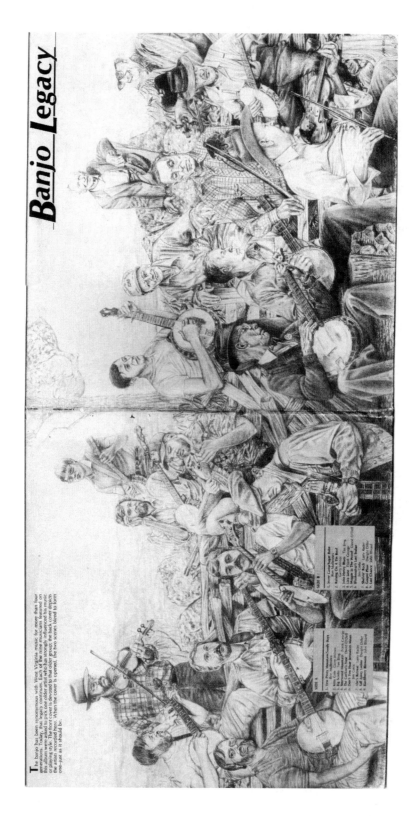

Banjo Legacy

The banjo has been synonymous with West Virginia music for more than four generations. Today, that legacy continues. Each of the nine musicians featured on this album were asked to pick one older artist who has strongly influenced his music or playing style. The front cover is devoted to that older group; the back cover depicts the artists recruited here. When the cover is opened, the two scenes blend to form one—just as it should be.

Banjo Legacy
1989

A delightful conversation with Ron Mullennex of Bluefield, Virginia, turned up interesting information about this complex Gayheart drawing.

Ron said that after attending music events in West Virginia, David Mould, a recording engineer at Ohio University, became interested in recording current musicians playing old-time banjo music.

Musicians were gathered and the music album was created and released through the Augusta Heritage Center at Davis and Elkins College in Elkins, West Virginia. The Heritage Center is nationally and internationally known for its work supporting programs involving the preservation of traditional folklife and arts. Each summer the Heritage Center sponsors five weeklong sessions, which include workshops in everything from traditional music to Celtic, Irish, Scottish, bluegrass, blues, Cajun, vocal, and dance.

The idea for the album cover was to use pictures of the performing musicians on the back cover and have the front album cover feature old-time musicians who were influential to each of the performers. Photographs were gathered, Ron Mullennex contacted Willard, and this is the result of that effort. One important note is that some of the featured performers who recorded on the album are shown with a fiddle in hand, but on the album everyone played a banjo.

Shown on the back cover (the left half) starting at the lower left: Dwight Dillard, banjo; above him is Frank George, banjo; in the plaid shirt wearing a hat and playing a fiddle is Jimmy Costa; just below Jimmy and beside Dwight is John Blisard, banjo; right next to Jimmy in the center is Ron Mullennex, banjo; lower right is Larry Rader on banjo; above him wearing a baseball cap is Tim Bing, banjo; to the upper left of Bing is Gerry Milnes, banjo; and at the top right is David O'Dell, banjo.

Featured on the front of the album cover (the right half) starting at the bottom left: Currence Hammonds, banjo; above him is Harlow Cales, banjo; to the right of Cales in the cap without an instrument is Sherman Hammons; below and center is Burl Hammons, banjo; lower right with cowboy hat is Bill Iman, fiddle; above Iman in plaid shirt is Harvey Sampson, fiddle; at the very top with no instrument is W. W. George; top right is Oscar Wright, banjo; and just below is Lee Hammons, banjo. All of these musicians in some way influenced the recording musicians.

Trimming the Stump
1989

Pauline Kleinke of Galax says, "[I was always told] we won't ever have a hurricane in these mountains, but someone forgot to tell that to Hugo in September 1989." The wind from Hurricane Hugo coming across the top of the hill on the Kleinke property "sounded like a train coming through the woods," Pauline recalled.

The storm resulted in large trees, pines and hardwoods, uprooting and falling all around the Kleinke home, over 35 in all blocking their roadway and making travel impossible. Neighbors got busy and cut all the trees out of the road, but they had to hire a man with a bulldozer to push the downed trees over the hill.

This drawing resulted from a photograph Pauline took of her husband, Chuck, as he trimmed the stump of one of the fallen trees.

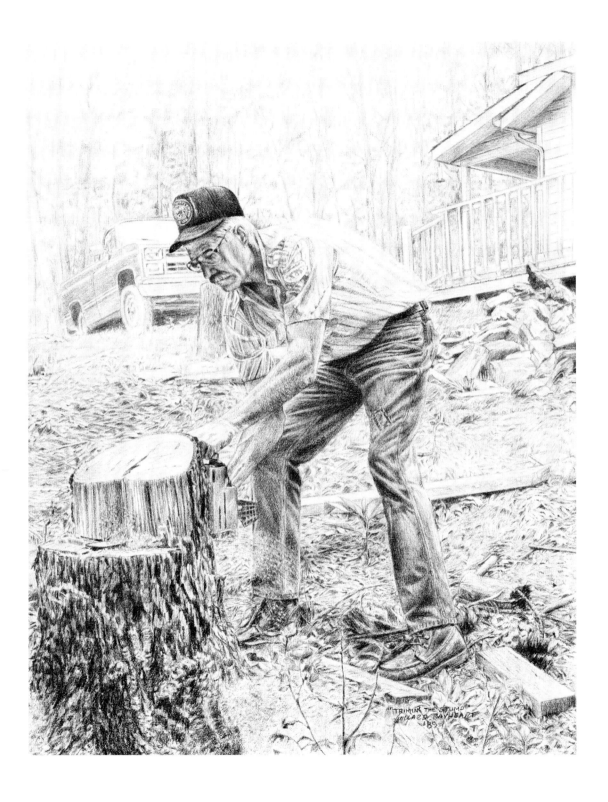

"TRIMIN' THE STUMP"
WILLARD GAYHEART
'89

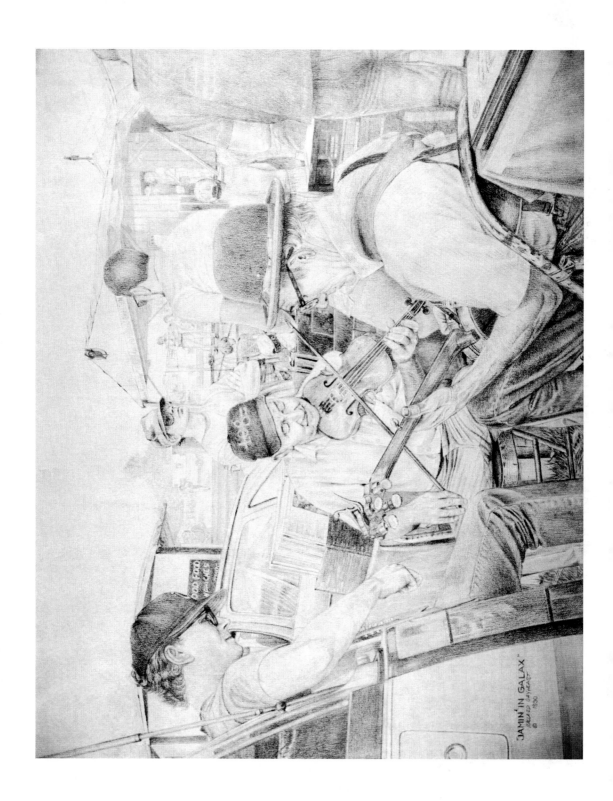

"JAMIN' IN GALAX"

Jammin' in Galax
1990

In 1988 a group of citizens from Galax, Virginia, formed the Galax Foundation for Excellence in Education to provide funding for students going on to college after high school. According to Susie Garner, executive director of the foundation, over a million dollars in scholarships have been awarded to Galax High School graduates as of 2011, and the foundation has an endowment of over $1.8 million. Proceeds from *Jammin' in Galax* print sales benefited the foundation.

The foundation commissioned Willard to do this drawing featuring Will Keys on the right. Will, a banjo picker, won a National Heritage Award, which is an award from the National Endowment for the Arts honoring traditional artists who are called National Living Treasures.

Will was from Trade, Tennessee. With him is J.P. Fraley from Carter County, Kentucky, playing the fiddle, and Dennis White on guitar, originally from Whitesburg, Kentucky, where he worked with Appalshop. The background depicts Appalshop workers at the Old Fiddlers' Convention in Galax.

Appalshop is a non-profit media, arts, and education center in Whitesburg, Kentucky. The center produces films, video, theater, music, and other recordings.

Arnie's Quest
1991

Arnie Solomon first attended the Old Fiddlers' Convention in Galax in 1971 when he was ten years old. He has missed only one since, in 1973.

Bill Monroe, the famed mandolin player known as the father of bluegrass and featured in the background of this drawing was a friend of Arnie Solomon's father. The young Arnie received his very first mandolin lesson backstage from Monroe at a New York performance. Arnie says he was fortunate to be able to join the legendary Monroe on stage a few times, the first when he was 12 and the last an appearance together at the Grand Ole Opry in Nashville, Tennessee, not long before Monroe's death in 1996.

This drawing was commissioned by Arnie's father in 1991, because, Arnie says, he admired Willard's work, "as simple as that."

Today Arnie lives in North Carolina where he sometimes uses his musical talent in creative ways to teach English as a second language.

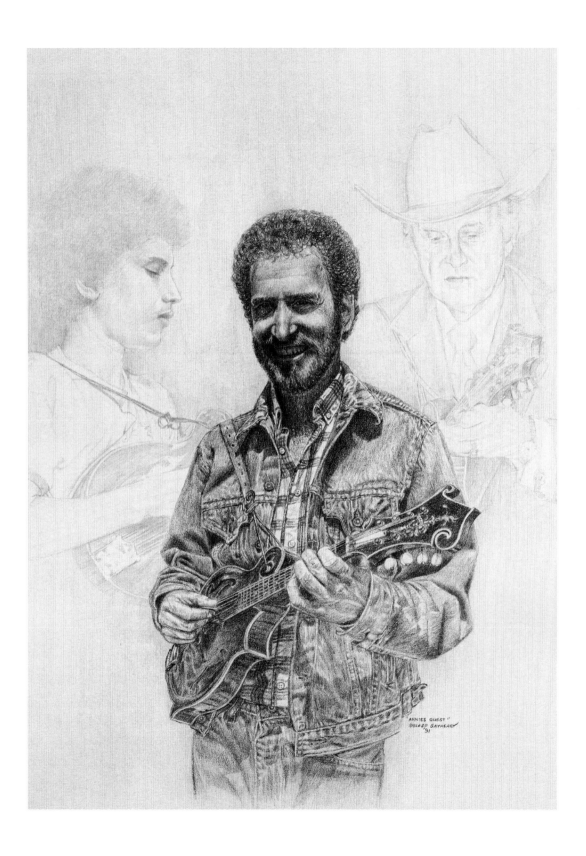

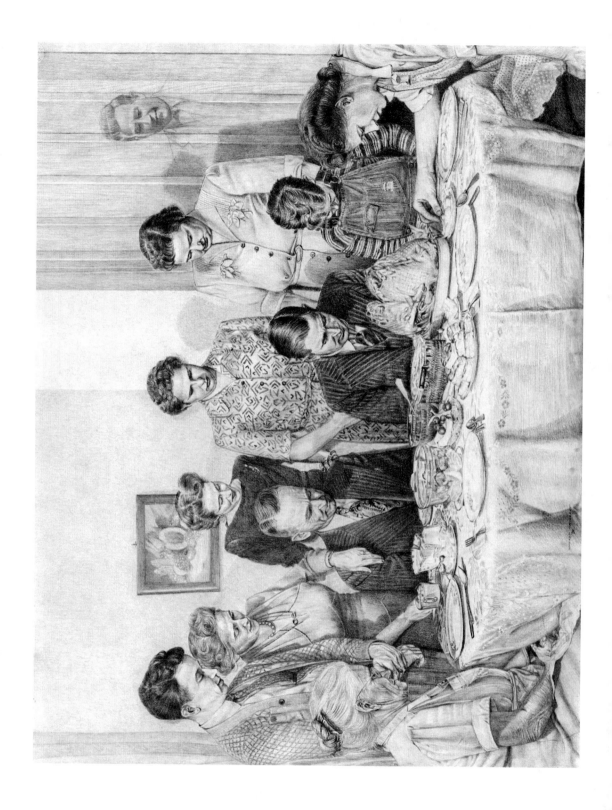

Family Gathering at the Homeplace
1992

Willard did this drawing in 1992 from a photograph taken in the mid 1940s at Jason David Wilson's family homeplace probably during a holiday celebration. Judging from the clothing, the holiday might have been Thanksgiving, Christmas, or an early Easter.

Jason Wilson grew up on the family homeplace owned by the Lowman side of the family on Haw Branch and the New River, now Claytor Lake. His mother's brother, Charlie Lowman, ran a ferry that crossed the river where Lowman's Ferry Bridge is now located on Lowman's Ferry Road. Jason's maternal grandparents built the farmhouse around 1910 and raised their family there. It is the same house where Jason was raised.

Jason is a descendant of Sam Cecil who began buying land on the New River in 1760, and Jason and his wife, Debbie Lineweaver, continue to live on the land that has been in the family for more than 250 years. They even continue to use the china shown in this picture.

A friend of the Wilson family, Edwin Lacy, who is also a close friend of Willard Gayheart's and is seen in many of Willard's drawings, "stole" the photograph to secretly commission a drawing as a gift for Jason. Edwin did not realize that Jason's father was away at the time the photograph was taken. Recently Jason took the drawing back to Willard and asked him to add his father "in spirit" because he was otherwise always a part of family gatherings. Now Jason Chumbley Wilson, who died in 1988, can be seen in the top right corner of the drawing.

The photograph was taken by Jason's uncle by marriage, Dan Riordan, who traveled the world for the Red Cross photographing disasters. Dan developed his own prints at a time when folks didn't have cameras and after these gatherings he would send pictures to the family, developing a pictorial history of the Lowman and Wilson families. Dan also photographed White House events, leaving behind great pictures of Eisenhower, Kennedy, and also Hollywood personalities.

In the drawing, seated from the left are Maggie Hurst Lowman, Oakley Howard, Charlie Lowman, and Evelyn Lowman Wilson. Standing are Bob Howard, Jessie Lowman Howard, Lottie Lowman Riordan, Doris Meredith, Geraldine Lowman, Jason at age 7 or 8, and Jason's father, Jason Chumbley.

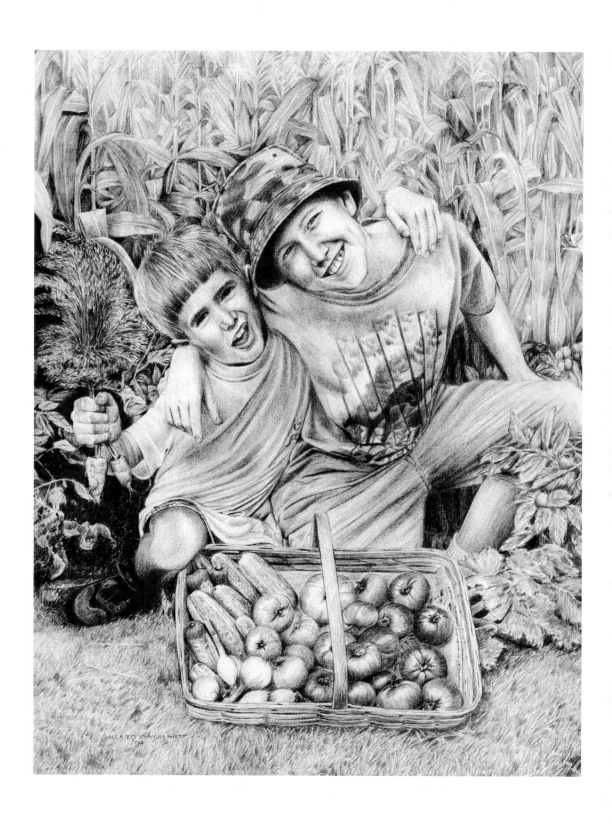

Goodbye, Swing Set, Hello, Garden
Will & Casey Smith
1992

Farron Smith, the boys' mother, described the setting for this drawing:

Our children were growing up. Will and Casey had outgrown their old swing set and the ground beneath the swings was bare with not a sprig of grass anywhere. Years of their little feet dragging beneath the swings had worn ruts in the dirt and mulch. It was sad to see the swings go, but a small garden in the area already cleared by our children playing sounded exciting.

Her husband, Bill, had grown up gardening with his grandmother and had fond memories of that time.

So the swings were replaced with a small garden—a couple of rows of corn, tomato plants, carrots, cucumbers, and whatever else could be squeezed in. It was a man's garden. Everything from preparing the ground to planting, watering, weeding, and harvesting was achieved by father and sons.

On this particular harvest day I was not at home and Bill searched for a basket that would hold the day's bounty. He found what he considered the perfect one—my only Longaberger basket! The basket I had admired but was much too expensive for our budget at the time. I'd pinched pennies until I finally had enough money to purchase the prized basket, the one I would put up and not use— it was only to be pleasing to the eye and hold delicate hand towels.

I came home to see my sweet boys and my proud husband after a hard day at work in their garden with my prized basket, filled to the rim with colorful vegetables—beautiful red tomatoes, golden corn, and carrots with their long roots coated with dirt ... dirt and more dirt in my beloved Longaberger. For a moment, or more, I was upset—until he snapped the picture!

The basket is not important now, but Bill and I both laugh at that day so long ago. We treasure Willard's drawing from that picture in the garden that brings to life a wonderful memory of our boys' childhood.

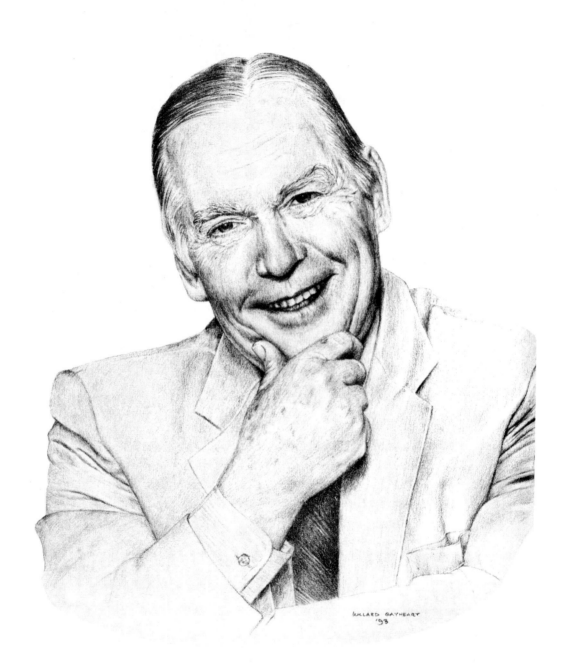

WILLARD GAYHEART
'93

Dr. Bob Stamper
1993

The late Dr. Bob Stamper was an active and community minded Presbyterian minister who served the Whitetop Presbyterian Church in the Mount Rogers area of Virginia.

Uncle Dave
1994

Dave Sturgill "was an interesting fellow, a character, a musician, builder of instruments, and a storyteller who could spin a yarn." He owned Sturgill Guitars and lived in Piney Creek near Mouth of Wilson, Virginia.

Willard gave this drawing to his and Dave's friend, Rick Abrams, for his birthday during the annual Father's Day Bluegrass Festival in Grass Valley, California. Rick was a journalist and old-time musician who played the clawhammer style banjo. He always hosted Willard and his band, Skeeter and the Skidmarks, when they traveled to play in the California bluegrass festival.

The original of this drawing belongs to Rick Abrams' widow and prints are available at the Front Porch Gallery in Woodlawn, Virginia.

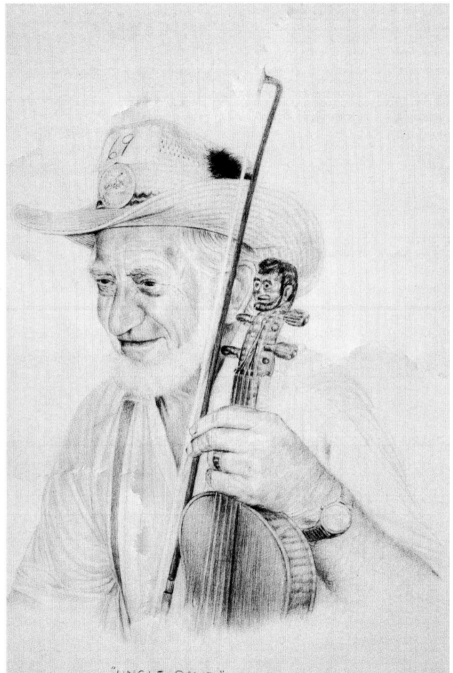

"UNCLE DAVE"
WILLARD GAYHEART
'94

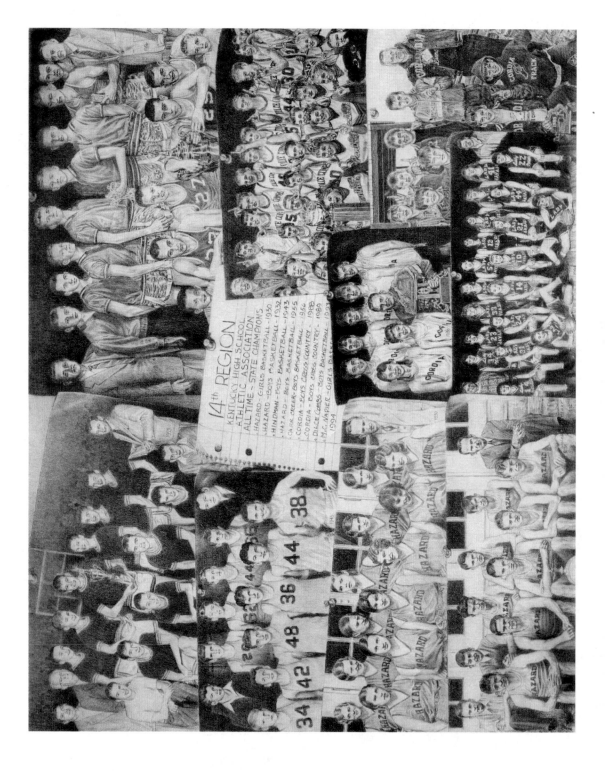

14th REGION
KENTUCKY HIGH SCHOOL
ATHLETIC ASSOCIATION
ALL TIME - STATE CHAMPIONS
HAZARD - GIRLS BASKETBALL - 1930
HAZARD - BOYS BASKETBALL - 1932
HINDMAN - BOYS BASKETBALL - 1943
CARR CREEK - BOYS BASKETBALL - 1955
CARR CREEK - BOYS BASKETBALL - 1956
CORDIA - BOYS CROSS COUNTRY - 1988
DILCE COMBS - BOYS CROSS COUNTRY - 1989
M.C. NAPIER - GIRLS BASKETBALL -
1994

14th Region Kentucky High School
1995

Commissioned in 1995 by the cross country coach Elmer Ray Combs at Willard's school in Kentucky, the drawing was to be a fundraiser for the Cordia Alumni of the 14th athletic region. Elmer Ray and Willard grew up there in the Lotts Creek area.

The drawing features the state championship teams from Carr Creek, Hindman, Delice Combs, Perry County, Central, Cordia, and Hazard, Kentucky, which until 1995 were the only state championship teams.

Of interest are the connections between these teams. In 1932 Hazard won the state championship and a young man named Morton Combs played on the team. In 1956 Car Creek won, and Morton Combs was the coach. Twin boys are featured in the drawing of that 1956 team, the sons of Morton Combs. One of the sons is Glen Combs, an All-American from Virginia Tech in the 1960s who now lives in Roanoke, Virginia. Glen's son Christopher played football for Duke University and for the Pittsburgh Steelers. Morton was Willard's mother's first cousin.

Willard says there are lots of stories in this one drawing and it took the longest of any to complete, a month and a half.

The original was sold in Hazard, Kentucky, to an unknown buyer.

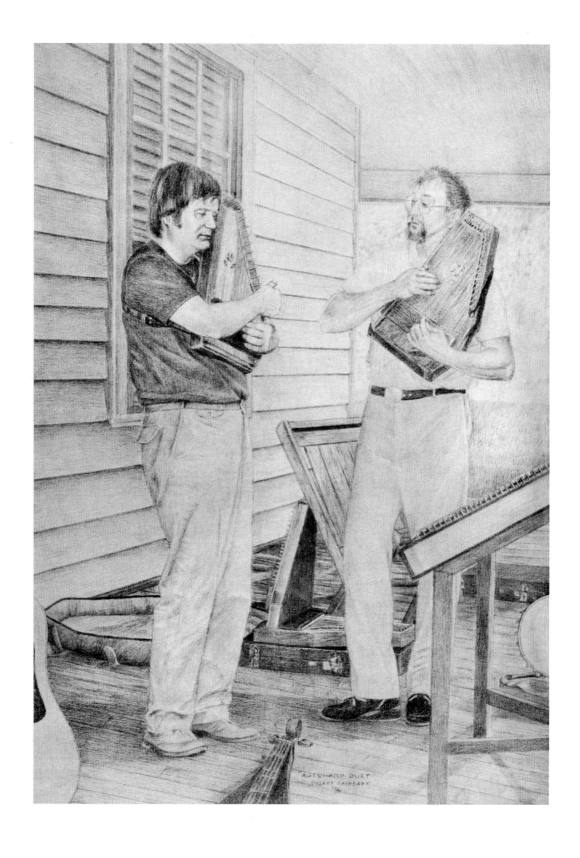

"AUTOHARP DUET"
DILLARD GATHEART
'96

Autoharp Duet
1996

Two great autoharp players and friends, Mike Fenton and Bryan Bowers, are the subjects of this drawing commissioned by Mike in 1996.

Mike, on the left, is from England. He speaks fondly of Willard, the late James Lindsey, and of Bobby Patterson as friends who have given him musical support and great friendship over the years during his trips to the United States.

In 1982 Mike won the first of three blue ribbons at the Old Fiddlers' Convention in Galax and in 1987 he won the International Autoharp Championship in Winfield, Kansas. He has taught autoharp classes in the United States at the Augusta Heritage Center in Elkins, West Virginia, and at the Ozark Folk Center in Mountain View, Arkansas. He is the only member of the Autoharp Hall of Fame.

On the right is Bryan Bowers, "one of the greatest autoharp players in the world," says Willard. Born in Virginia, Bryan relocated to Seattle, and over the years has become a master at the autoharp. He is also a singer, songwriter, and storyteller.

Rosa Lee & Doc, Fifty Years Together
1996

Rosa Lee & Doc was commissioned by Wilkes Community College as a gift to the Watsons in celebration of their 50th wedding anniversary on June 9, 1996. Willard drew the couple and their children, Merle and Nancy, at different times in their lives.

In summer of 2011 Willard, Ricky Cox, and Donia visited Doc in his home in Deep Gap, North Carolina, for the purpose of scanning this drawing for publication. We spent a wonderful afternoon with Doc and his daughter, Nancy, who lives on the family property, while Willard and Ricky removed the large piece from its frame, scanned it, reframed it and returned it to Doc's wall. We tried not to be awestruck by the legendary seven-time Grammy award winner.

Doc welcomed us into his modest home and the acclaimed musician moved with ease through the dimly lit rooms while Willard and Ricky worked on the drawing. Doc, blind since infancy, commented that though he had never seen the drawing he had known Willard for a long time and knew his drawings were good because people had told him so.

Conversation was easy with Doc Watson that day, but he made it clear he didn't much like a lot of praise. "I'm just one of the people," he would say, and Willard had found over the years in his association with Doc that "he would just clam up if I started to praise him."

Doc's faith was very important to him, as is Willard's. Months earlier, while waiting backstage to perform with David Holt at the Blue Ridge Music Center, Doc took my hand and talked about his faith, a powerful low-key witness from a man who said, "Honey, I'm not afraid to die." Not many months later, in May 2012, he did, but on the day of our visit to Deep Gap he spoke of his beloved Rosa Lee, the loss of Merle, and his faith as his daughter Nancy stood protectively close by.

Before we left Doc's homeplace we enjoyed visiting Nancy at her cottage and seeing some of her art. Ricky even grabbed a ladder and cleaned the overflowing gutters around the cottage for an appreciative Nancy. We thought our visit with Doc was done, but there he came, walking slowly across the expanse of lawn between his house and Nancy's. Standing under a tree with low hanging leaves, he identified it as a sassafras tree and began to talk of its benefits, including making a nice tea.

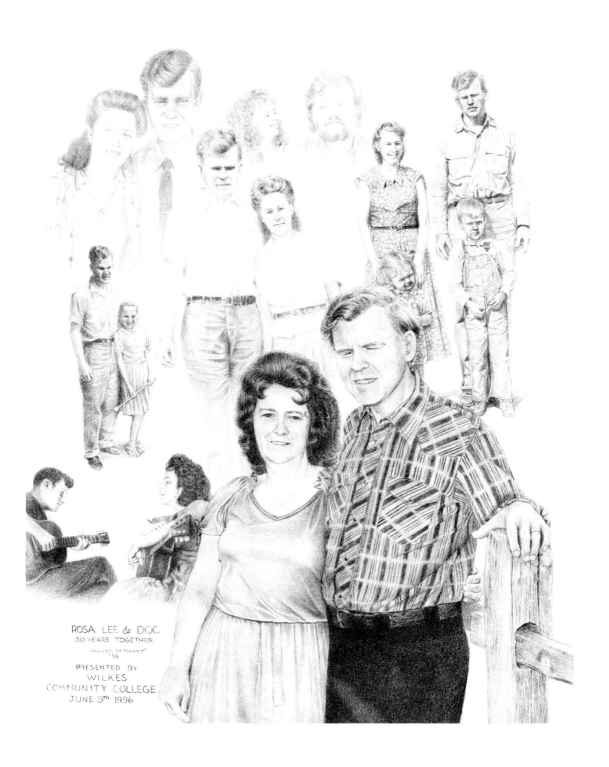

ROSA LEE & DOC
50 YEARS TOGETHER
HILLARD GAYHEART
'96
PRESENTED BY
WILKES
COMMUNITY COLLEGE
JUNE 5th 1996

John Jackson
1997

It was for his own enjoyment after meeting a special gentleman at the Chatauqua Festival in Wytheville, Virginia, that Willard drew John Jackson. He was from Fairfax, Virginia, and a man Willard describes as "one of the nicest men I've ever met with the best manners and soft way of speaking. He made you feel so comfortable and was an absolutely amazing person." Jackson died in 2002.

Well known in blues music circles, Jackson was a grave digger by trade but traveled the world with his music. He played a Piedmont style blues guitar, a style that is said to be comparable to ragtime.

Jackson was friends with another blues duo, Cephas and Wiggins, subject of a drawing featured in the first book about Willard's art, which was published in 2003.

The original drawing was raffled as a fundraiser for the Galax Chamber of Commerce during the Old Fiddlers' Convention in 1997. The owner is unknown.

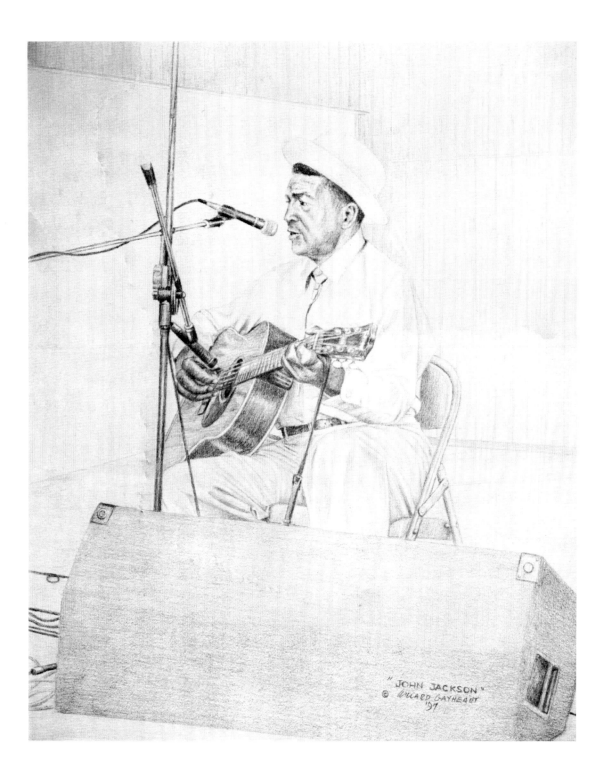

"JOHN JACKSON"
© WILLARD GAYHEART
'97

Study of a Legend
1997

Used as a fundraiser for the Galax Chamber of Commerce in 1997, this drawing features Kyle Creed, a sought-after musician, and according to Willard, "a legend in old time music circles."

Creed, now deceased, was noted for building banjos and for his unique picking style. Willard said he was famous for the clarity in noting the banjo. He used a brass homemade pick on his index finger and played a wonderful drop thumb style clawhammer banjo. "He was much imitated and mentored many young aspiring banjo players."

"STUDY OF A LEGEND"
© Willard Gayheart '97

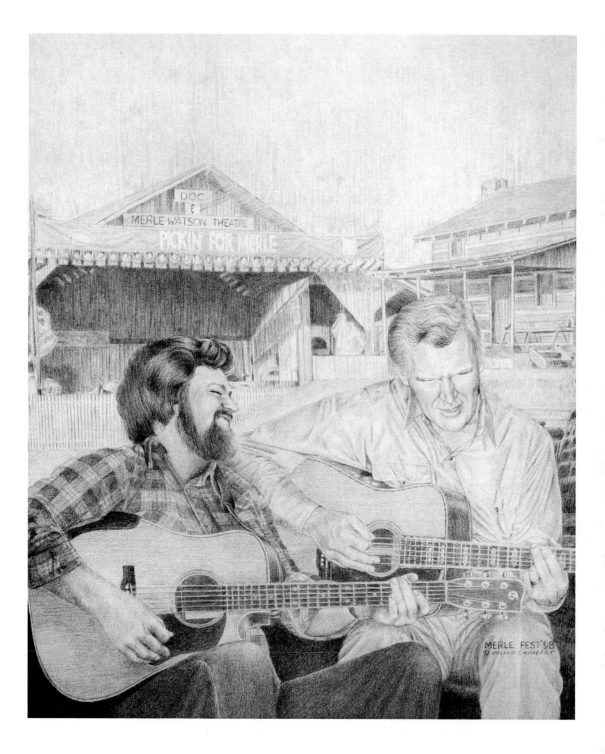

Merlefest
1998

Merlefest 1998 was the last year Willard created the official poster for the festival which had been started 10 years earlier in memory of Merle Watson, Doc and Rosa Lee Watson's son. Merle died in a tractor accident in 1985. Routinely raffled as a fundraiser for the festival, in 1988 the last poster was given to Doc and Rosa Lee in honor of Doc's 75th birthday.

Held in Wilkesboro, North Carolina, the last weekend in April and hosted by Doc Watson until his death in 2012, Merlefest attracts thousands of people who flock to the four-day event to hear top name musicians spread across some 14 stages. The festival is the main fundraiser for Wilkes Community College.

Willard created the Merlefest posters in 1994, 1995, 1996, and 1998.

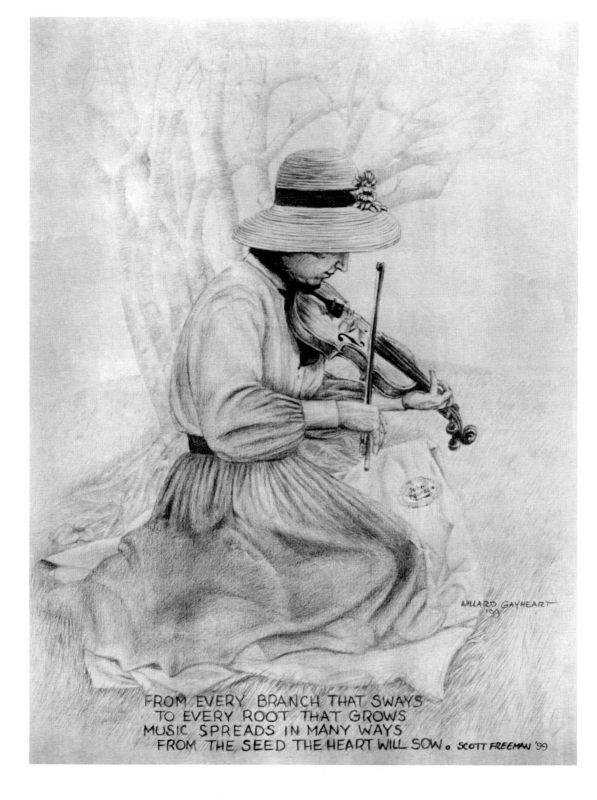

FROM EVERY BRANCH THAT SWAYS
TO EVERY ROOT THAT GROWS
MUSIC SPREADS IN MANY WAYS
FROM THE SEED THE HEART WILL SOW. SCOTT FREEMAN '99

WILLARD GAYHEART
'99

Music Spreads
Katy Taylor
1999

The first time Katy Taylor met Willard Gayheart was at the Ramp Festival in Whitetop, Virginia, probably in the spring of 1987. He was selling his art there and Katy was charmed by his sketches. She bought a print of *Lesson for Brian* (1984, shown on page 34 of the first book) that day because her father, Fred Taylor, had been in the Whitetop Mountain Band with Albert Hash.

Katy saw Willard again in the early 1990s when she played in a band with his son-in-law, Scott Freeman. Scott and Willard went on to form the band Skeeter and the Skidmarks and Katy was a fan. Later, Willard recorded *Nostalgic Glimpses of the Appalachians*, and Katy's friend Tony Testerman played bass on some of the cuts. Katy "was happy to tag along to the studio." Tony's stand-up bass had a "buzz," which could only be remedied by having someone apply pressure to the back of the bass while it was being played. Katy did the job and claims with humor, "Technically I was on that project!" She went on to say, "I thought then that Willard was a great singer/songwriter."

In the fall of 1997 Scott and Willard approached Tony and Katy about coming together to do a show at Tweetsie Railroad in Blowing Rock, North Carolina. Skeeter and the Skidmarks had disbanded, Willard and Scott were hoping to start a new band, the vocal blend of Willard, Katy, Scott, and Tony was good, and with the addition of Randy Paisley on resophonic guitar the Alternate Roots Band was formed. A while later Steve Lewis on banjo joined the group and between November 1997 and January 2006 the band recorded four CDs.

While recording their second project in Mount Airy, North Carolina, Willard photographed Katy for a sketch he had in mind to publicize Alternate Roots. Katy wore a hat with a brim and held Scott Freeman's fiddle under a tree behind the studio. Katy said, "The funny thing is, I don't play the fiddle!" She says she may be the only subject of a Gayheart drawing who is portrayed doing something he or she can't do.

Portrait of a Legend
Doc Watson
1999

Willard recalled that this drawing was done as a fundraiser for the annual Doc Watson MusicFest at the Cove Creek School in Sugar Grove, North Carolina, and the donated original hangs there in the small Doc Watson Museum.

A print of this drawing is one of Willard's prized possessions because of the signatures shown on the guitar. Willard's son Michael attended a concert at Radford University featuring Doc, guitarist Jack Lawrence who played and traveled with Doc after Merle's death, and Doc's grandson Richard Watson. Michael took the print backstage and witnessed the three men signing it, reporting back to Willard that Richard held Doc's hand so that he could write his name.

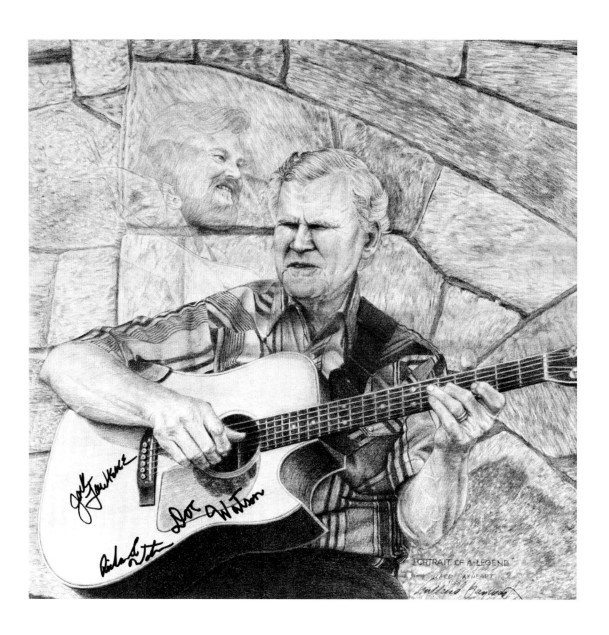

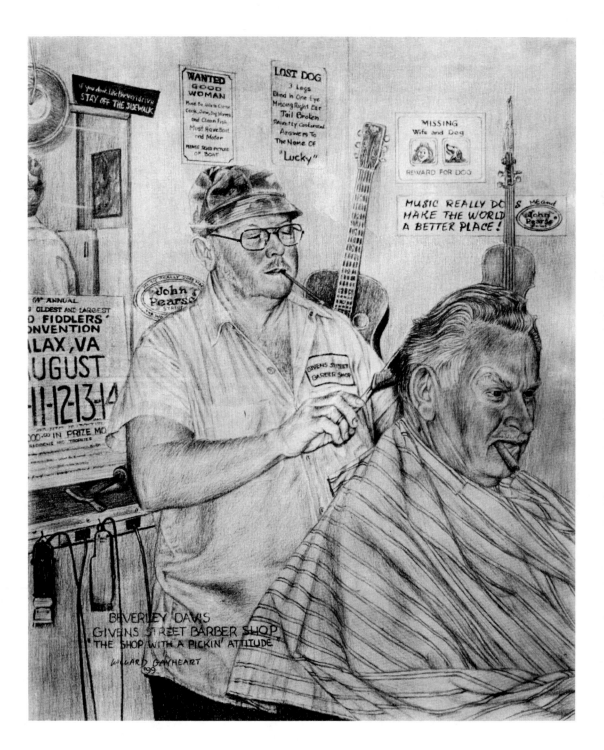

The Shop with a Pickin' Attitude
Beverley Davis
Givens Street Barber Shop
1999

Beverley Davis is the subject of this work commissioned to raffle and raise funds for the Old Fiddlers' Convention in Galax. The winner of the drawing is unknown.

Willard says, "Davis was a good musician and a character!" He was a banjo picker who also taught and played the guitar and dobro. His barbershop was peppered with humorous signs, some featured in the background of the drawing.

The "customer" in the drawing was actually one of the other barbers in the shop.

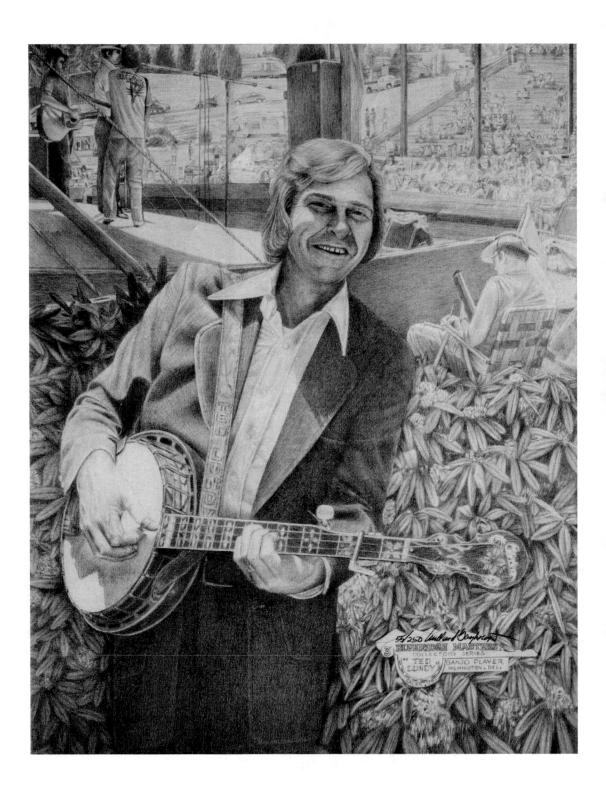

RIVERIDGE MASTERS
COLLECTORS SERIES
"TED LUNDY" BANJO PLAYER
WILMINGTON, DEL.

Ted Lundy
Blueridge Masters
Late 1990s

The drawing of Ted Lundy belongs in a series done by Willard entitled "Blueridge Masters." Ted was a banjo picker and guitarist who became involved in music around age 8, and was playing Earl Scruggs–style banjo by age 14. His band, the Southern Mountain Boys, played festivals and music circuits until Ted's death in 1980.

This drawing, a commission by Ted's son Bobby, was taken from the cover of one of Ted's albums entitled *Lovesick & Sorrow* which he did with Bob Paisley on the Rounder record label. Bobby said he wanted Willard to do a drawing of his dad so he gave him the album cover and told him to take it from there and he did, filling in the background.

The original hangs in Bobby's home in Delaware. Prints are still available at the Front Porch Gallery in Woodlawn, Virginia.

Festival Go'ers
2001

In 1993 Cheryl Bolen fed her daughters ice cream as she stood near Willard at the Galax Old Fiddlers' Convention. Willard photographed the family and in 2001 he used the photograph to create this drawing for the Chamber of Commerce as a fundraiser.

Tiffannie is the oldest daughter. Whitney is the youngest and a good friend to Dori, Willard's granddaughter.

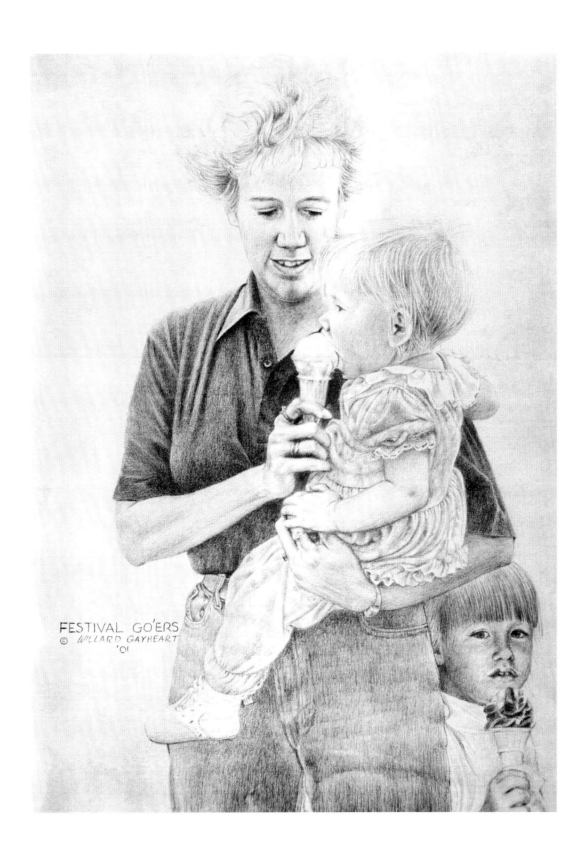

FESTIVAL GO'ERS
© WILLARD GAYHEART
'01

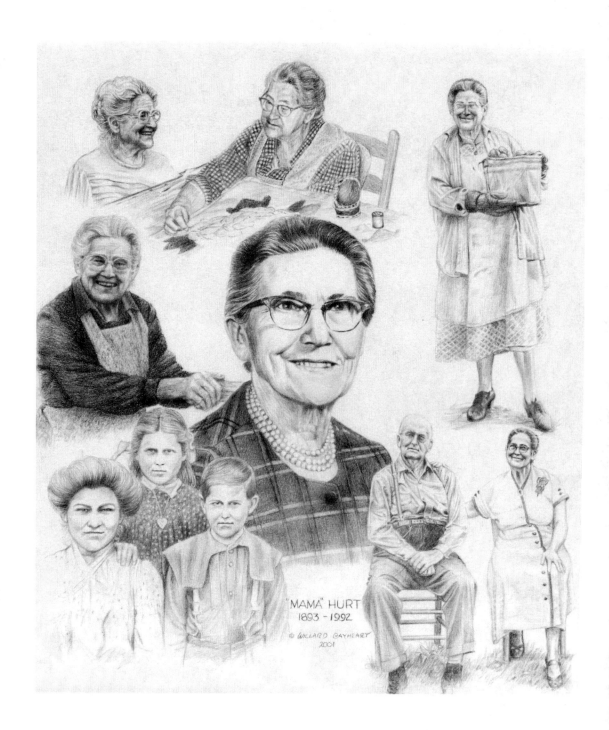

"MAMA" HURT
1893 – 1992
© WILLARD GAYHEART
2001

Mama Hurt
2001

This drawing was commissioned by Willard's good friend Elmer Ray Combs. It features Elmer Ray's mother-in-law, Ollie Hurt, who lived to be 99 years old. The drawing depicts Mrs. Hurt at different stages of her life. She lost her husband at an early age and raised her family on Lotts Creek near Hazard, Kentucky, where both Willard and Elmer Ray grew up.

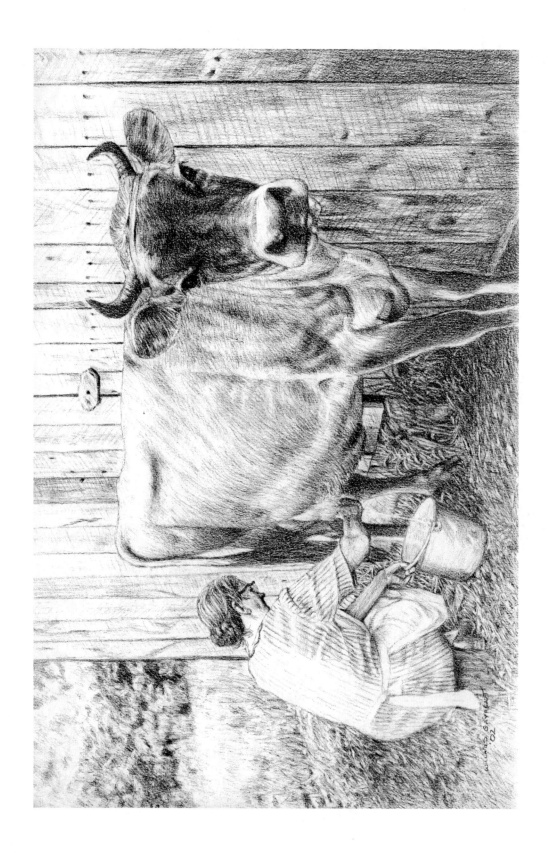

Alma Edwards
2002

Alma Edwards, the subject of this drawing, was widowed in 1937. Her husband Montie died at age 35 of pneumonia, leaving Alma with three children. Wallene was 11 years old, Pearl was 6, and Argie, the youngest, was born a month after Montie's death. Alma went on to raise her three daughters alone on their fourteen-acre farm.

Alma Edwards knew how to live off the land. She planted a vegetable garden each year, kept chickens for eggs and bartering, and relied on Betsy the cow for milk. The daughters helped their mother on the farm until they were old enough to work away from home and earn extra money.

Alma made the quilts the family used in cold winters and she made all their clothes. Argie, Wallene, and Pearl would choose dresses they liked from the Sears and Montgomery Ward catalogs and Alma created the patterns and sewed the dresses. Feed sacks were used whenever possible or Alma would trade chickens or eggs for fabric.

Today Argie lives in the Woodlawn, Virginia, area near the family farm. Pearl lives nearby in Carroll County, and Wallene died in 1977 at age 50. Alma Edwards died in 1989 at age 92.

Argie and her sister-in-law, Glenda Light, persuaded Willard to create the drawing using a photograph taken of her mother milking the family cow. Argie was in her teens when she took the photograph.

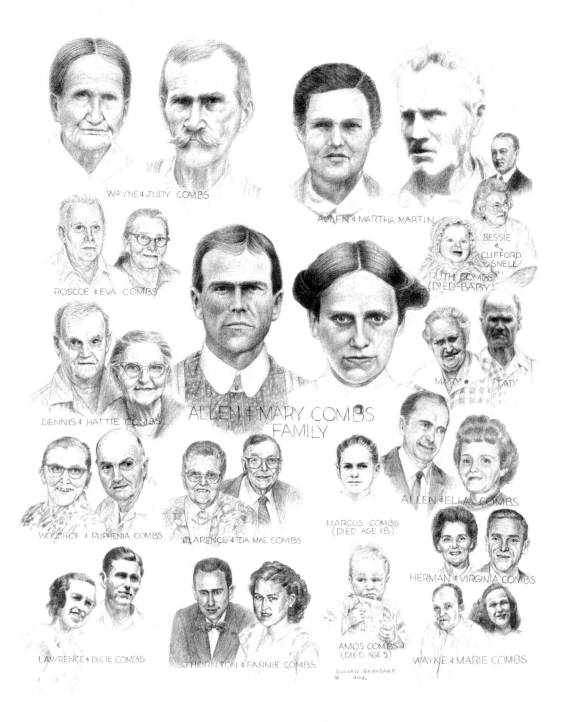

WAYNE & JUDY COMBS

ALLEN & MARTHA MARTIN

ROSCOE & EVA COMBS

BESSIE & CLIFFORD SNELL

RUTH COMBS (DIED-BABY)

DENNIS & HATTIE COMBS

ALLEN & MARY COMBS FAMILY

MARY & "TAD"

WOODROE & RUPHENIA COMBS

CLARENCE & IDA MAE COMBS

MARCUS COMBS (DIED AGE 18)

ALLEN & ELLA COMBS

LAWRENCE & DICIE COMBS

THORNTON & FANNIE COMBS

AMOS COMBS (DIED AGE 5)

HERMAN & VIRGINIA COMBS

WAYNE & MARIE COMBS

WILLARD GAYHEART ® 2002

Combs Family
2002

Another drawing commissioned by Willard's good friend Elmer Ray Combs includes Elmer Ray's father's immediate family on the Combs side, the Allen and Mary Combs family. Willard has drawn Elmer Ray's grandfather, grandmother, great grandfather and great grandmother, as well as other family members.

The family was English, arriving in Jamestown in the 1600s before settling in the Lotts Creek community near Hazard, Kentucky, about 1800. The whole family lived in the area around Lotts Creek where Willard also spent his childhood.

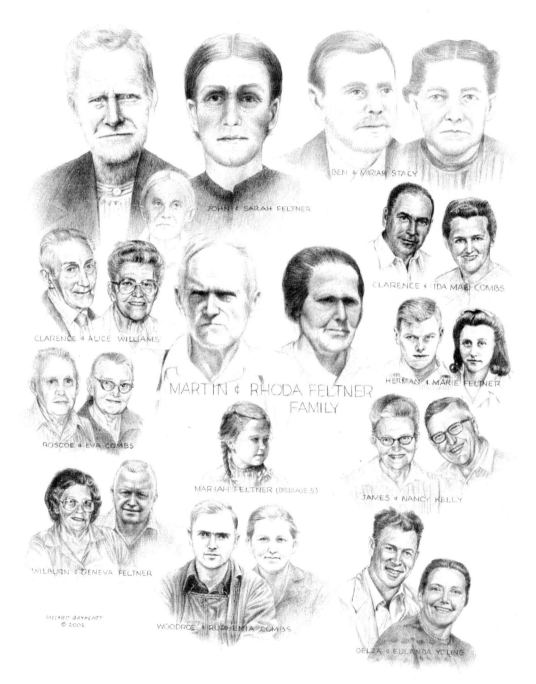

BEN & MIRIAH STACY

JOHN & SARAH FELTNER

CLARENCE & IDA MAE COMBS

CLARENCE & ALICE WILLIAMS

HERMAN & MARIE FELTNER

MARTIN & RHODA FELTNER
FAMILY

ROSCOE & EVA COMBS

MARIAH FELTNER (DIED AGE 5)

JAMES & NANCY KELLY

WILBURN & GENEVA FELTNER

WILLARD GAYHEART
© 2002

WOODROE & EUPHEMIA COMBS

DELZA & EULANDA YOUNG

Feltner Family
2002

The Feltner family, in-laws of Willard's longtime friend Elmer Ray Combs, is captured in this drawing. They are the Martin and Rhoda Feltner family.

Willard stated he and Elmer Ray went back as far as they could in the family and gathered many photographs to create the drawing. He recalled, "Back then families were quite large."

Papa's Favorites
2002

These are Willard's only granddaughters—Sarah, 4 at the time, and Dori at age 10. Grandfather Willard is picking blackberries with his granddaughters during Sarah's fourth birthday celebration on a July day at son Steven's home.

Willard said, "Someone took a photo which I used, but I added a few things. For example, in the background you can see a dog that belonged to Dori. I put him in to kindly add to the picture."

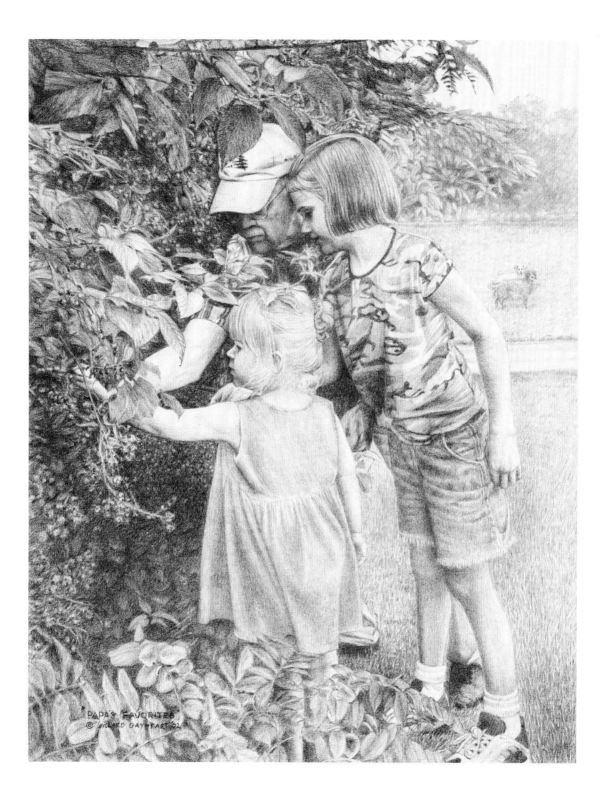

"PAPA'S FAVORITES"
© WILLARD GAYHEART 02

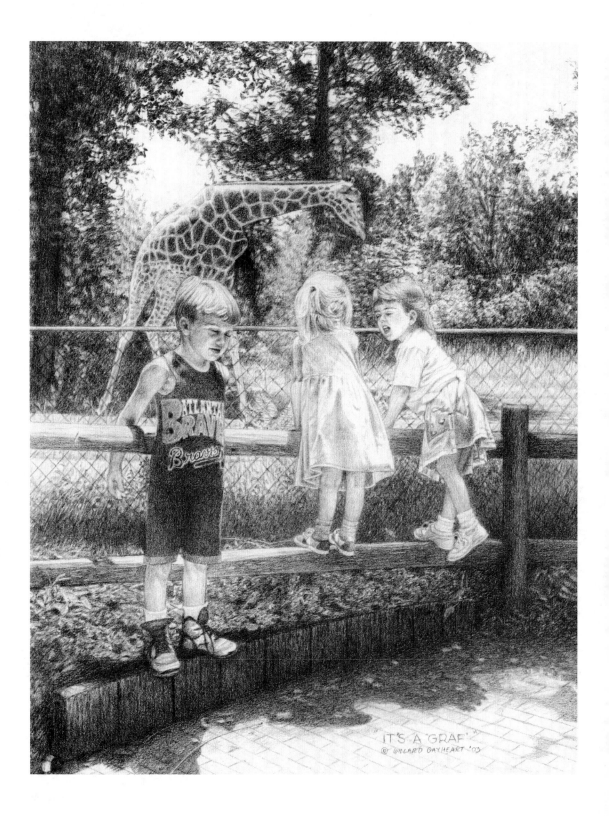

"IT'S A 'GRAF'"
© WILLARD GAYHEART '03

It's a Graf
2003

Some years ago, in the 1990s, Willard's granddaughter Dori visited a Tennessee zoo with her parents, Scott and Jill Freeman, and friends. Jill took a photo of the children at the zoo. Willard used that photograph and a subsequent one he took of a giraffe during a later trip with Dori to a North Carolina zoo. He imagined the chattering little girls calling the animal a "graf" as the little boy looked away, "not much interested in their conversation."

Dori is now 21 years old and actively pursuing a career in music. Influenced by singer, songwriter, composer, and actress Peggy Lee, Dori performs with her father Scott, grandfather Willard, and others in Boone and Blowing Rock, North Carolina; Heartwood in Abingdon, Virginia; the Blue Ridge Music Center; and other venues throughout Southwest Virginia. On some Friday evenings she performs with her father and grandfather at the Fiddle and Plow, a weekly music event held at the Front Porch Gallery, the family business in Woodlawn.

Dori has two CDs out, *The Porch Light* and *Those on the Moon*. Joe Wilson of the National Council for the Traditional Arts writes that Dori's music reaches across time and place, from her great grandmother's Kentucky cabin to the music that made its way from New Orleans to Chicago, and now she reaches toward good music everywhere, embracing it with her rich voice.

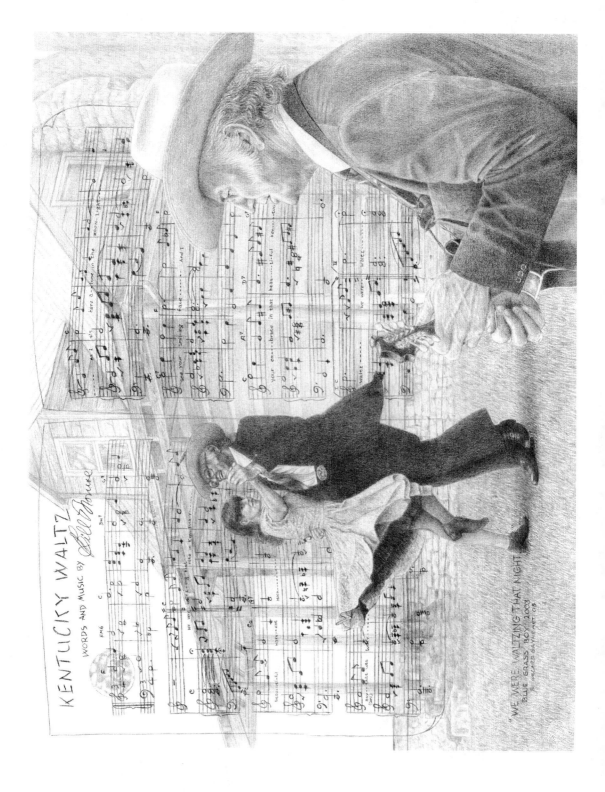

We Were Waltzing That Night
Blue Grass Boy
2003

Since 2000 Willard Gayheart has created the official prints for the Bill Monroe Festival, probably better known as the Blue Grass Boys' Reunion. The prints were commissioned through 2011, the year of the musician's 100th birthday, by Doug Hutchins, an associate of Bill Monroe for some 25 years, and the organizer of the event, which brings together former members of the Blue Grass Boys' Band.

Each year at the reunion the new drawing was unveiled. Hutchins provided the song title each time and Willard took it from there to the finished product. "We Were Waltzing That Night" is the first line from Monroe's famed "Kentucky Waltz." Hutchins found the sheet music to the waltz and Willard chose to make it the background of the drawing. It features Bill Monroe's signature showing clearly on the music.

Willard recalls the drawing as "quite challenging."

Monroe's dance partner in the drawing was one of the Green Grass Cloggers, a dance group from East Carolina University that traveled all over the country.

Will Keys
A National Treasure
2003

Will Keys from Tennessee was awarded a National Heritage Fellowship from the National Endowment for the Arts in 1996 for his contributions to traditional music. In 1993 the National Council for Traditional Arts featured Keys in the Masters of the Banjo tours.

Willard met the musician in 1978 when Keys won the Old Fiddlers' Convention in Galax. Willard was impressed with his picking style, describing it as "so unique, different from anything I'd ever heard or seen, and he was so personable and made quite an impression on a lot of people with his signature derby hat and ability."

Keys played a two-finger style. He began playing early in life and his first instrument was made by his brother using wire from a screen on the back door.

Willard's drawing was used to benefit the Galax Chamber of Commerce in a raffle.

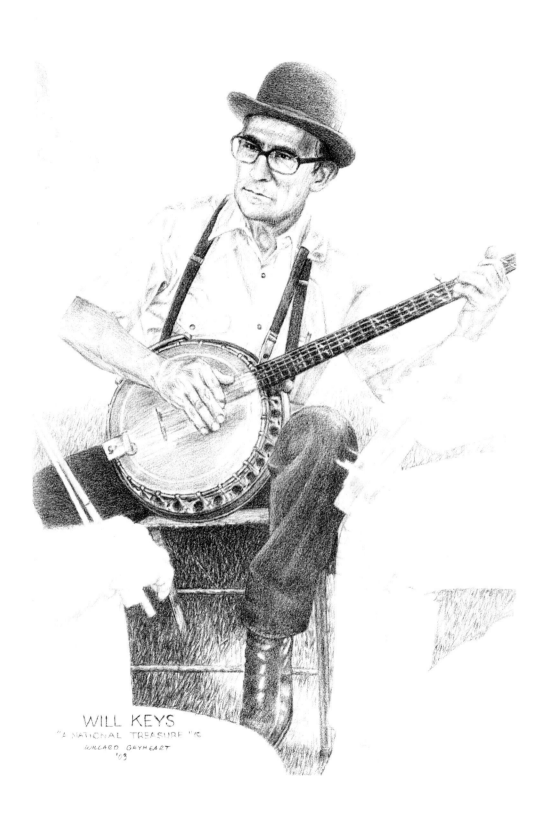

WILL KEYS
"A NATIONAL TREASURE"
WILLARD GAYHEART
'03

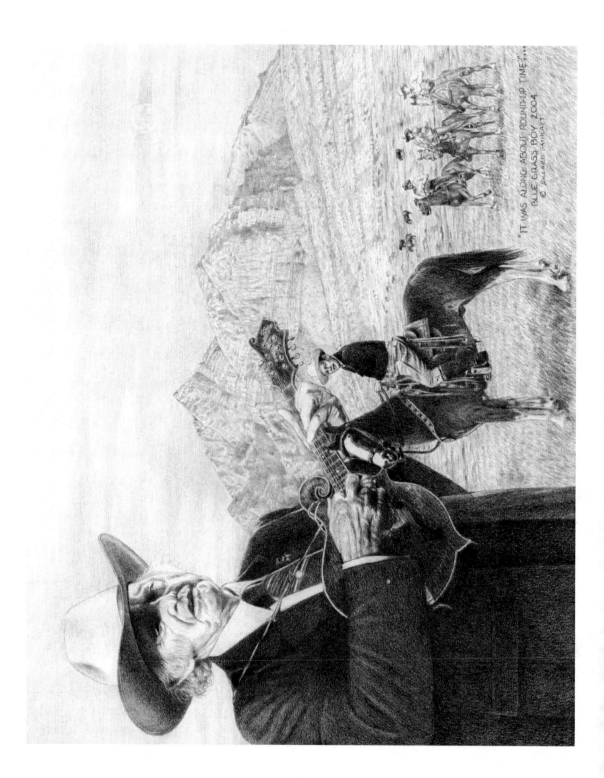

"IT WAS ALONG ABOUT ROUND-UP TIME"....
BLUE GRASS BOY 2004
© BALLARD GATHEART

It Was Along About Round Up Time
Blue Grass Boy
2004

This is another in the series of posters for the Bill Monroe Festival. The title is the first line in the song, "Goodbye Old Pal," a kind of western song Monroe wrote.

Willard said, "I put him in a different setting than you generally find him, out west on a horse. The horse he owned back in the 1950s was a well-known horse to his bluegrass fans. Bill called him King Wilkie."

All of the Monroe Festival drawings hang in the Bluegrass Museum in Owensboro, Kentucky.

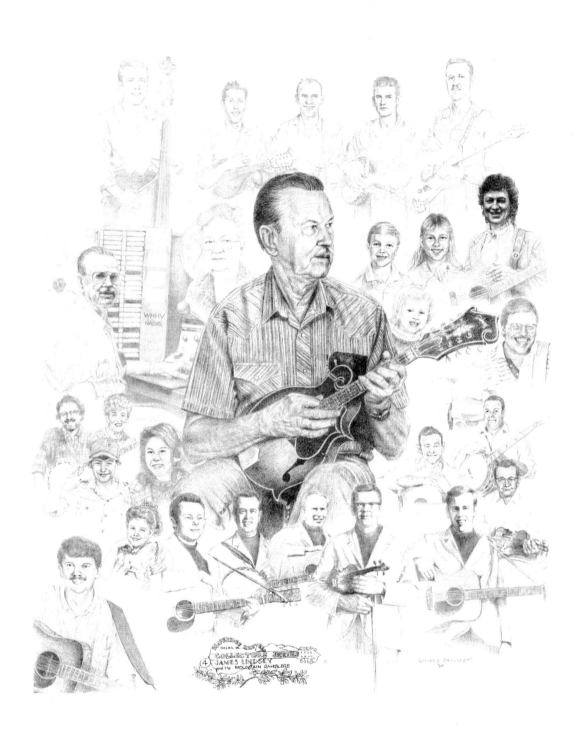

COLLECTORS SERIES
(4) JAMES LINDSEY
and the MOUNTAIN RAMBLERS

James Lindsey
Blueridge Masters
2004

James Lindsey had the longest running traditional band in this country, the Mountain Ramblers, the first band Willard Gayheart played with in the late 1960s. Started in the '50s, the band won regularly at the Galax Old Fiddlers' Convention in the '60s and '70s, and continued to perform until James' death.

After the death of James, his son Larry asked Willard to create a drawing of James and some of the musicians who played with the band over the years. Willard drew many of the former band members as well as James' family members, including his wife by his side, Larry in the lower left corner, and grandchildren Brandon and Whitney.

The original hangs in Larry's home and other prints have gone to family and band members.

Willard remarked, "James Lindsey made quite a contribution to traditional music and was dedicated to the music."

John Viers
2004

John Viers' son Brent commissioned this drawing as a gift for his father in 2004. John and his family live in the Hiwassee community of Pulaski County, Virginia, where he is a well-known musician. He plays banjo, guitar, autoharp, and dobro.

The drawing features two musicians who were influential to John growing up. He could turn on his radio and hear the two—Don Reno and Red Smiley, popular country/bluegrass musicians in the 1950s and '60s.

Earl Scruggs was another motivator in John's life, and he recalled picking with Earl in 1966 in South Boston, Virginia, at the National Guard Armory. Viers remembered Earl played an original Gibson banjo, a design that was one of only five made by Gibson. A photograph of the two playing together is a prized possession. At the time, John was a member of a band, Virginia Buddies, with Richard Bishop, and they opened for concerts by Flatt & Scruggs.

The cabin in the background of the drawing, John said, was an old slave cabin in the community of Draper, Virginia, that was taken down, moved, and rebuilt on Claytor Lake and is still in use today.

John Viers has led an interesting life. A 1970 winner of the National Banjo Championship put on by the Country Music Association in Warrenton, Virginia, this man who didn't learn to read until the 1960s was elected a member of the governor's convention on literacy in Richmond and went on to attend conferences on a national level. A promoter of literacy, he set up a small library branch in the country store he owned in Pulaski County. In 1979 he attended a literacy and library conference in Washington, D.C., and played the banjo for President Jimmy Carter at the White House.

John has also developed a history of the banjo from Africa to the Appalachians which he has presented in schools, he's played at the Grand Ole Opry, performed for Russians visiting Virginia businesses, and these days continues to preserve the music through his contributions to the Crooked Road, Virginia's Heritage Music Trail.

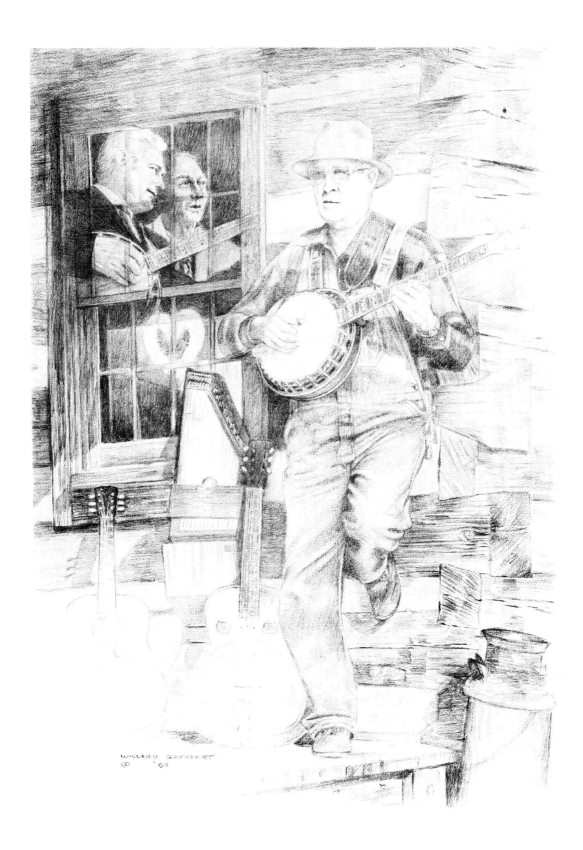

WILLARD GAYHEART
© '07

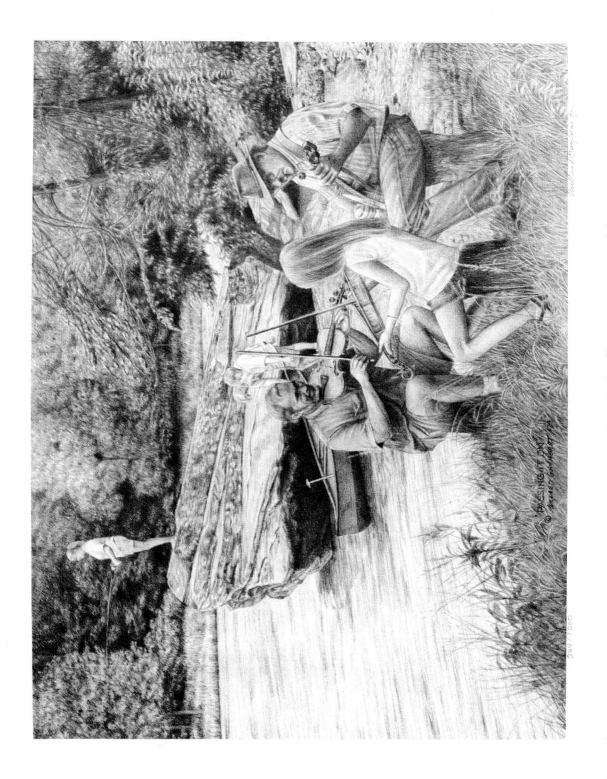

PASSING IT ON
© HAROLD GRANROSE '94

300/1000

Passin' It On
2004

Tom Smith, the 2004 Chairman of the National Committee for the New River, photographed his wife and two daughters along the river near Mouth of Wilson and Willard donated this drawing to the committee as a fundraiser.

Approximately 1,000 prints were made to benefit the work of that committee and can be purchased at the office for the committee located in West Jefferson, North Carolina.

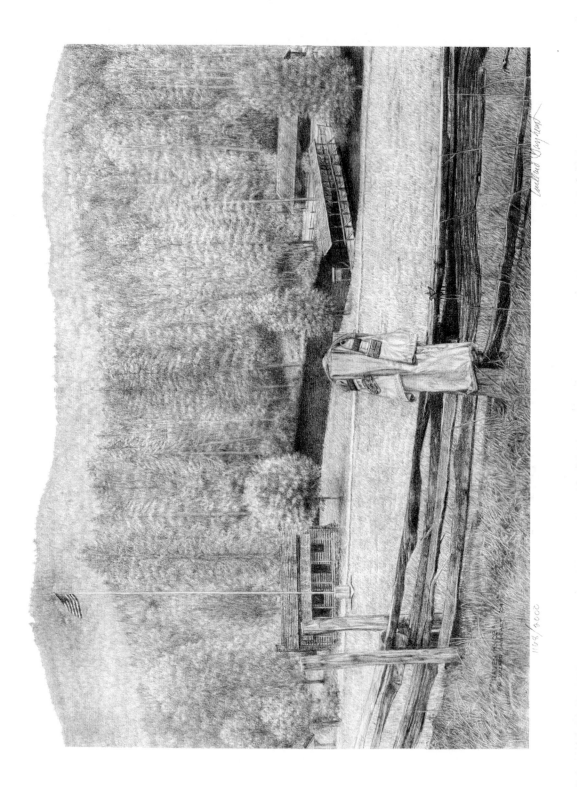

Raven Knob
2004

Raven Knob is a Boy Scout camp for the Old Hickory Council in Low Gap, North Carolina, "a beautiful place that's very busy in the summertime," remarked Gayheart.

This drawing was done as a fundraiser for the camp and the original hangs in the Boy Scout Museum at Raven Knob. Sales of the prints went to benefit the camp.

Willard said, "It was quite a challenge because it's outdoors with a lot of trees and I had to come up with an idea that was unique to portray the camp, so instead of putting pictures of scouts in there I hung a shirt on the post that was symbolic of the scouts and included some of the buildings around the camp."

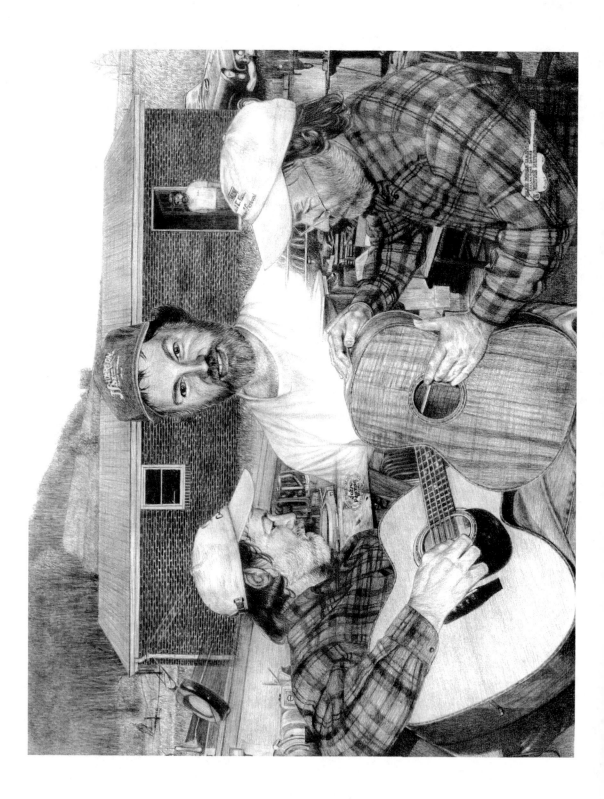

Welcome to Wayne's Shop
Blueridge Masters
2004

"I did this just to be doing it. I'd done one earlier in exchange for my Henderson guitar but thought maybe I'd do this one too. It shows Wayne's shop and some of the items in there and some of the notable things that identify Wayne."

Wayne's longtime pet turkey, "Schmedley," the source of many funny stories told by Wayne, is in the background at the far left. Rumor has it that the turkey threatened anyone who came near. The story is that Wayne trained him to do this. A prized possession, Wayne's vintage 1950s Thunderbird is on the right. The workshop is in the background with Wayne in the doorway; in the foreground Wayne is shown playing a guitar on the left, a younger Wayne is in the center, and on the right he's doing what he loves, fashioning a guitar from coir wood.

Willard says the drawing has "done okay." He goes on to say, "Wayne has a lot of fans and friends across the country and anything I can do for Wayne, well, I do it."

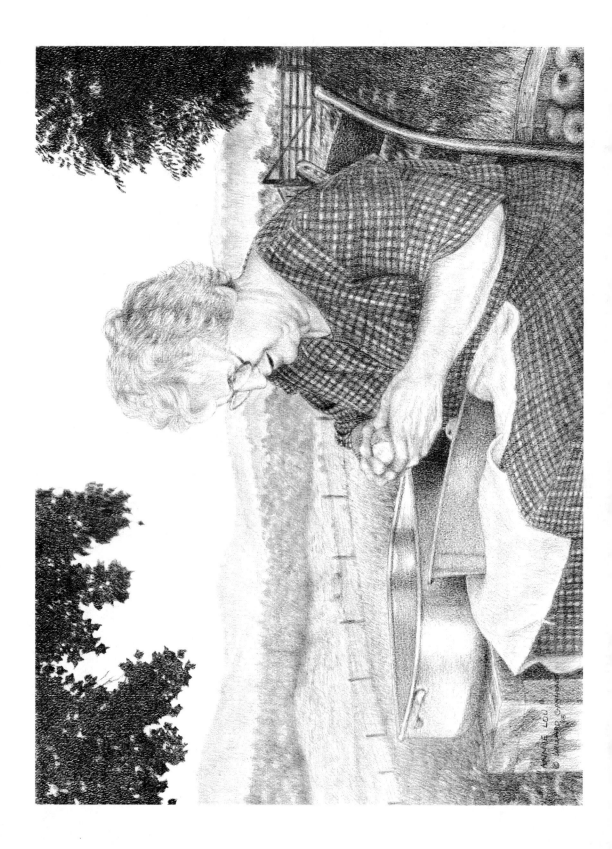

Annie Lou
2005

This drawing of Annie Lou "Mamaw" Wallace was commissioned by her granddaughter Pam Barlow, of Jefferson, North Carolina, as a Christmas gift for Pam's mother in 2005. The original photograph was taken in a garage at Annie Lou's home in the Bristol community of Jefferson when Pam was in her teenage years and her grandmother was in her early 70s.

Willard said, "I moved her outside and put some of our mountains in the background and kindly emphasized the Blue Ridge. Annie Lou represents a Blue Ridge mountain lady going about her daily chores and in the fall one of them would have been peeling apples."

Pam Barlow, upon seeing the drawing for the first time, was "amazed" that Willard, without knowing, had drawn the background just as the scene would have been from Annie Lou's back yard. According to Pam, "he got every check in her dress just right" and even captured the partially amputated left thumb on Annie's hand, the result of an accident involving an axe. Each family member has a print of Annie Lou.

Brother Sheffey & Gideon
2005

Robert Sheffey was a legendary religious figure during the late 1800s. Sheffey lived in Staffordsville, Virginia, and is buried at Trigg in Giles County, Virginia.

The Saint of the Wilderness, a book about his life, was written by Jess Carr and later made into a movie by Bob Jones University.

The original of this drawing was sold at the Galax Lord's Acre Sale.

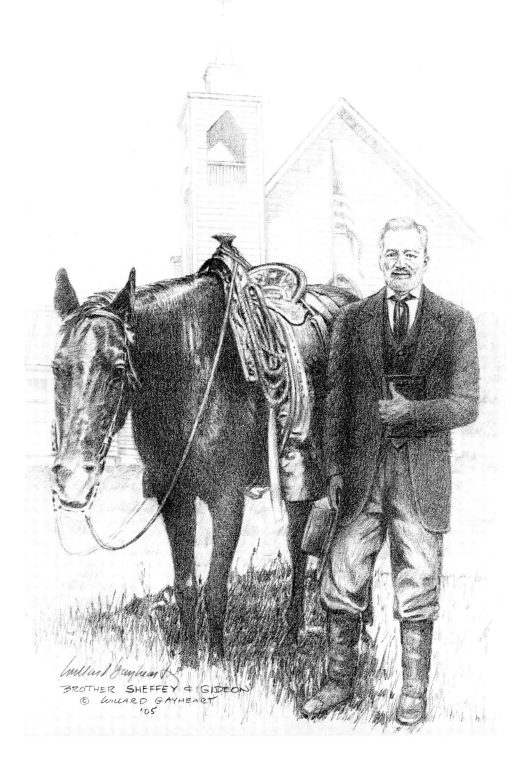

BROTHER SHEFFEY & GIDEON
© WILLARD GAYHEART
'05

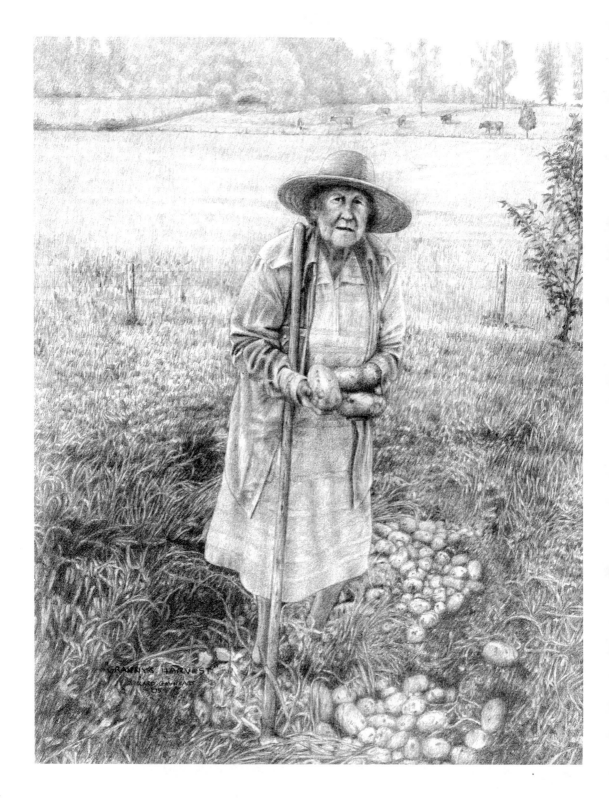

"GRANNY'S HARVEST"
RICHARD GRANGEAT
05

Granny's Harvest
2005

This lady—Edith Riffe of Monroe County, West Virginia—has been gone since 2002, and Willard did the drawing from a photograph brought to him by her son, Ron, who said, "I realized I had to capture her when she was in her 80s. She fed the world."

According to Willard, "That summer they'd raised a big patch of potatoes, she and her son, and she was so proud of those potatoes. It was quite a patch. It's turned into a real popular print because it's so typical of our Appalachian culture, and Granny is a woman a lot of people can identify as being like their own grandmother or other family member."

"Mom has been all over the country as a result of this drawing," said Ron. "Nobody went away from her house hungry."

From the Depression era until her death Granny Riffe took care of people. According to her son Ron, two of the people she helped care for were Cap Hatfield and his wife. Cap was the son of legendary "Devil Anse" Hatfield of the famous feuding families, the Hatfields and McCoys.

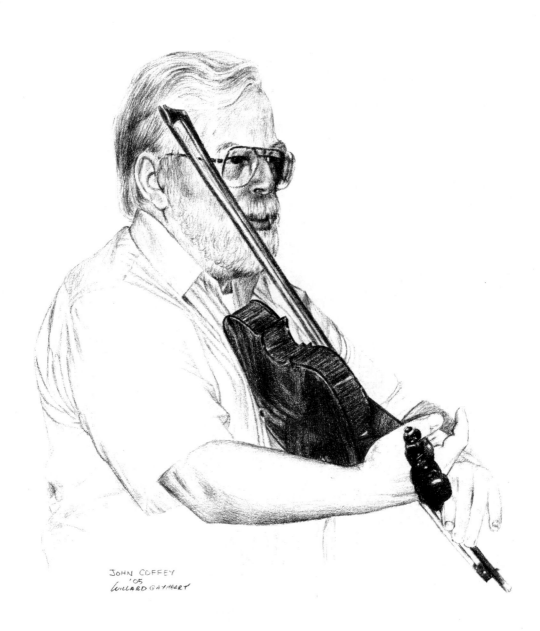

JOHN COFFEY
'05
WILLARD GAYHEART

John Coffey
2005

John Coffey is a left-handed fiddler from Galax. Willard described him as a walking encyclopedia on old time traditional music with an astounding record collection.

He was also a long-time nurse anesthetist at the hospital in Galax and upon his retirement the staff commissioned Willard to do this drawing for him.

John was married to Betsy Rutherford, a well-known traditional musician also featured in this book in the drawing entitled *Wildwood Flower* done in 2006.

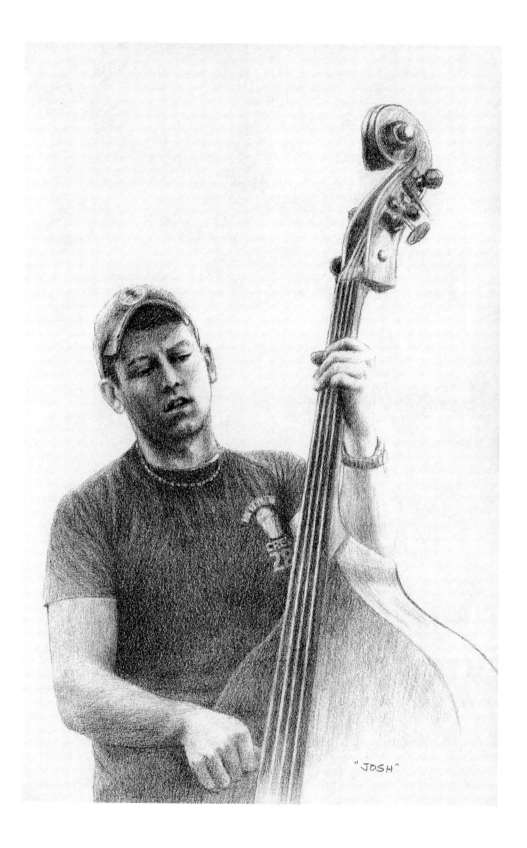

"JOSH"

Josh Scott
2005

Josh Scott, a great bass player according to Willard, lives in the Boone, North Carolina, area and is the stepson of another well-known musician, banjo player Steve Lewis.

Willard did the drawing as a birthday surprise for Josh, and he presented the drawing to him at a concert at the Todd General Store in Todd, North Carolina. "He is really a good fellow and I just wanted to draw it," he said.

Josh plays bass frequently with Willard's son-in-law Scott Freeman, with David Johnson, Steve Lewis, and other musicians.

Let Freedom Ring
2005

According to Willard,

I was a guest at the 4th of July celebration in Independence in 2005, and they wanted me to do the drawing for their festival. They had a big raffle and raffled off the original. The title of the drawing was a theme they wanted used, "Let Freedom Ring."

They gave me the idea and I had to come up with the drawing so I chose the courthouse in Independence, which is a quite famous courthouse, as kind of the central part of the drawing to represent our government. Then there's the school, Bridle Creek School, and a church nearby, Peach Bottom Primitive Baptist, and the Liberty Bell symbolizing freedom. I used the flag and a farmer and folks canoeing on the New River. It all kindly depicts Grayson County and the culture of the county, an example of our freedoms in this country.

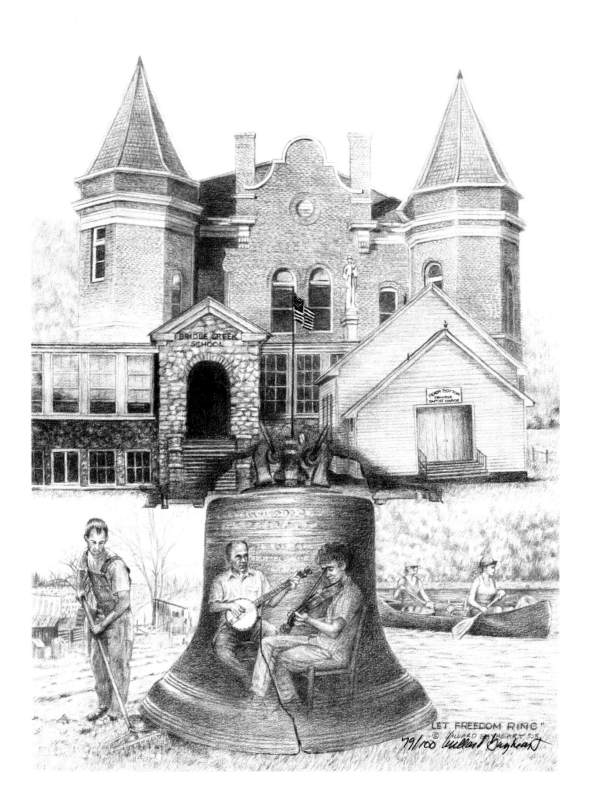

"LET FREEDOM RING"
79/100

The Road Is Rocky
Blue Grass Boy
2005

Taken from the Monroe song, "The Road Is Rocky But It Won't Be Rocky Long," this sixth drawing in the Bill Monroe Festival series features a young Monroe in the background. Included with Bill is one of his early influences—Arnold Shultz, an African American blues musician from central Kentucky.

Willard spoke of Shultz's talent:

> *He influenced Monroe greatly and Bill said one time if he hadn't learned to play the mandolin so well he would have wanted to play the guitar just like Arnold Shultz. I always suspect that some of the bluesy sounds we hear in our bluegrass music that Bill Monroe started come from Arnold, and Bill's association with him.*

This drawing hangs in the Bluegrass Museum in Owensboro, Kentucky.

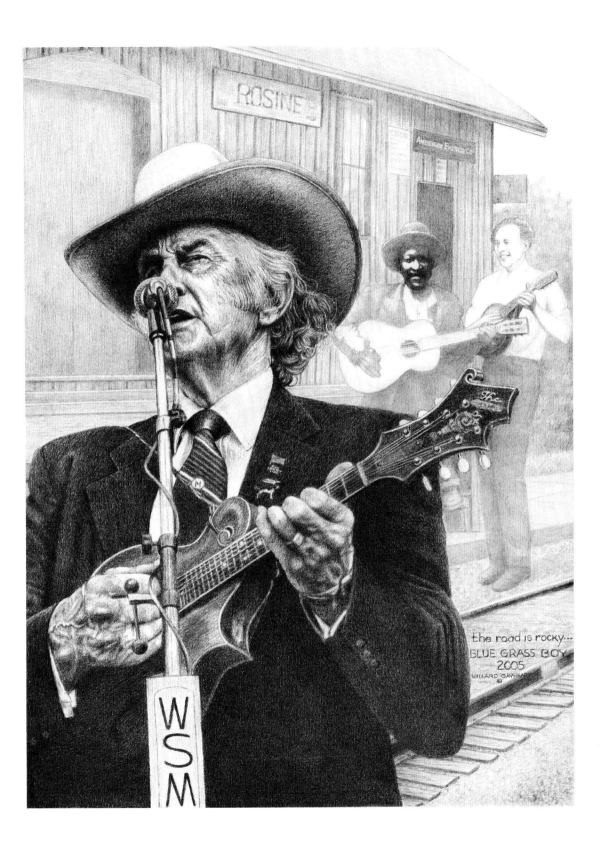

ROSINE

the road is rocky...
BLUE GRASS BOY
2005

WSM

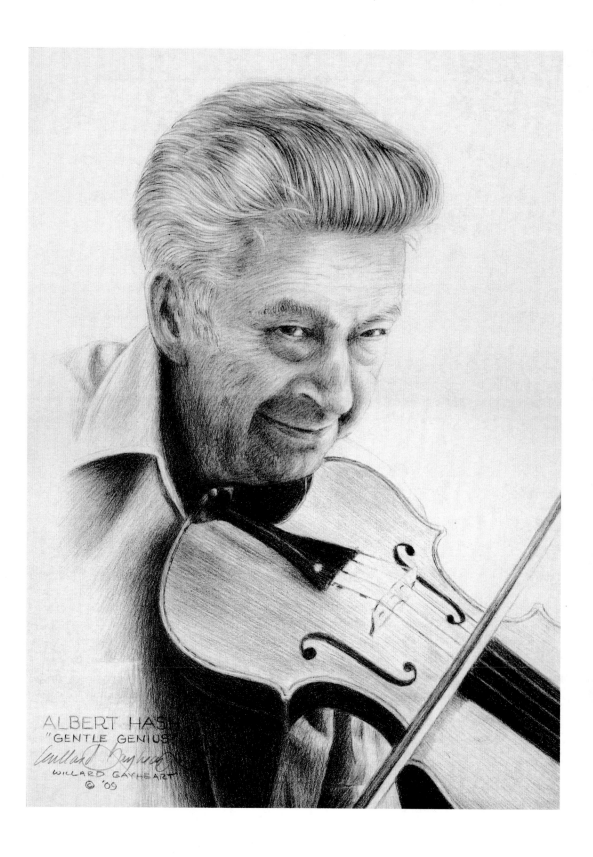

ALBERT HASH
"GENTLE GENIUS"

Willard Gayheart
© '09

Albert Hash
Gentle Genius
2006

Albert Hash, from Rugby, Virginia, was a well-known fiddler and fiddle maker who started making instruments during the Depression era when he was just 10 years old. Throughout his life until his death in 1983 he shared music with many and his talents were celebrated all over the country. Perhaps he is most remembered for helping start an old-time music program at Mt. Rogers Combined School in Whitetop, Virginia (closed in 2010). The program continues today at Grayson Highlands School, teaching students old-time music, and the school band is called the Albert Hash Memorial String Band.

Willard donated this drawing for the Albert Hash Memorial Festival, held in early September every year. They sold the original and 25 prints to help raise funds to support the festival. The original is owned by Jon Lohman, Virginia's folklorist.

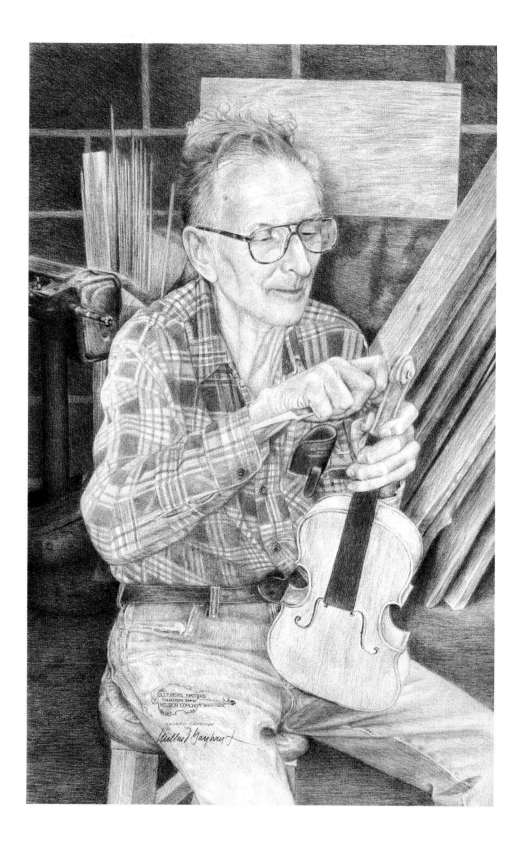

Nelson "Harry" Edmonds
Blueridge Masters
2006

Music runs in the Edmonds family. Nelson, known as Harry, was a musician who worked in a furniture factory and was also a builder of instruments. His creations were unusual in that he changed the instrument body designs by making the back and sides of his instruments all in one piece. His theory was that the fewer glued joints in an instrument the better the sound.

Harry's daughter, the late Barbara Poole, was a bass player and traveled all over the country performing with banjo player Larry Sigman. Barbara commissioned Willard to do this drawing of her father and had him make prints for her to sell at her concerts. She died a few years ago from cancer.

Jimmy Edmonds, Barbara Poole's brother and Harry's son, is a leading musician who once performed with the stage band at Carolina Opry in Myrtle Beach, South Carolina. These days Jimmy builds Edmonds Guitars and other instruments at Edmonds Guitar Shop in Galax.

Willard recalls, "Harry Edmonds was quite a fellow, just such a good man, one of the finest I've ever known. He would do anything for you, would lend his instruments to musicians, and was a wonderful craftsman. Some of his instruments are in museums, maybe even the Smithsonian."

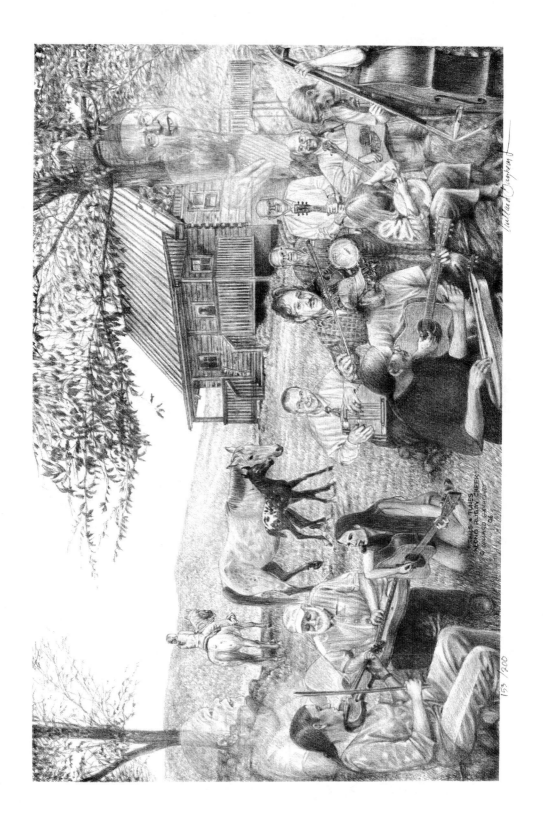

Tales and Tunes Along Rugby Creek
2006

Vicki Stuckert, a dulcimer recording artist from Findlay, Ohio, encountered Willard's art before she met him. But once she saw his work she wasted no time in getting to the Front Porch Gallery, on a mission to convince Willard to create a drawing for a very special project.

Vicki was preparing to record *Tales and Tunes Along Rugby Creek*, a book of Virginia songs and tunes for the mountain dulcimer. The project was aimed to benefit a horse rescue farm in Rugby, Virginia, just behind the home of musician Wayne Henderson. On the evening before Vicki was to record the songs the musicians gathered at Wayne's home for practice and Vicki noted "his home was filled with beautiful art." All the pieces were by the same artist, Willard Gayheart. Vicki had found the artist she would convince to draw the cover for her book. As soon as the recording session ended she drove to Woodlawn. "I walked into that gallery and was amazed at the beautiful drawings that filled the place. I was like a kid in a candy shop, wanting a sample of each and every drawing that had to do with music, and there were many!"

Willard himself greeted Vicki on that visit to his shop. She introduced herself and her work, explained about the recording and the effort for the horse rescue operation. She said that she wanted a cover on the book that would somehow include everyone who had contributed to the CD.

Vicki had lots of pictures for Willard, including one of a foal named Esperanza born on the day of recording and another of a cabin on a hill at the farm. She gave all these to Willard. He suggested that when you opened the cover and the pages hung down, there would be the entire drawing, like an old LP album cover. Vicki says, "It worked."

Willard came up with a beautiful scene, which included all the parts of the scene important to Vicki. He added two Virginia musicians whose songs Vicki used but who are no longer living, Kilby Snow and Kate O'Neil Peters Sturgill. He also donated one of his own songs to the project, "The Salet Song."

Vicki says this project evolved much like the Crooked Road in Southwest Virginia. It is the result of the talents, generosity, and cooperation of many people, but Willard Gayheart made it come alive visually for all who heard the music and saw the book.

Virginia Beauties
2006

Willard says,

Virginia Beauties *was done for a Relay for Life fundraiser and the sales went well. There were some real energetic people working with that organization that year and they got out and worked hard and sold prints.*

They wanted me to do a drawing that would depict Carroll and Grayson counties and the city of Galax. The apples represent Carroll County, the music Galax, and there's a sign on the wall behind the stove there about the White Top Mountain Festival back in the '30s that represents Grayson County, because back then they had one of the most famous traditional music festivals that's ever been in this country. It only lasted a few years. It was attended by Eleanor Roosevelt in 1932 or '33.

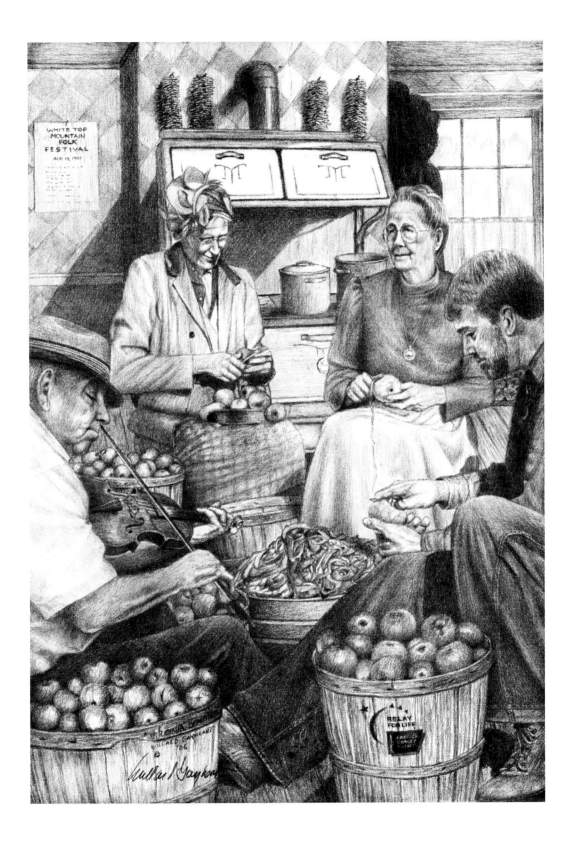

Wildwood Flower
2006

Betsy Rutherford, the subject of this drawing, died in 1991 at the age of 47. The drawing was done using a photograph taken of Betsy at the Old Fiddlers' Convention in the 1960s.

Sometime after the year the photograph was taken a Galax newspaper published several pictures of musicians and asked the public to identify them. John Coffey recognized his wife of 20 years and the newspaper gave him Betsy's photograph.

Betsy was born in Galax, Virginia, to a musical family but grew up in Baltimore and became a well-known performer of traditional music. She had a powerful voice with broad appeal and she played the autoharp. She was accompanied by her husband John, a fiddler and also a nurse anesthetist at the Galax hospital.

Willard named the drawing *Wildwood Flower* because of the Carter Family song by the same title, which also featured the autoharp.

Betsy's daughter Heather said that interest in her mother's music has increased over time and that now she even has a Facebook page created by a fan in California.

John Coffey continues to live in Galax. Upon his retirement from the hospital his coworkers commissioned Willard to do a drawing of John, also featured in this book, as a gift.

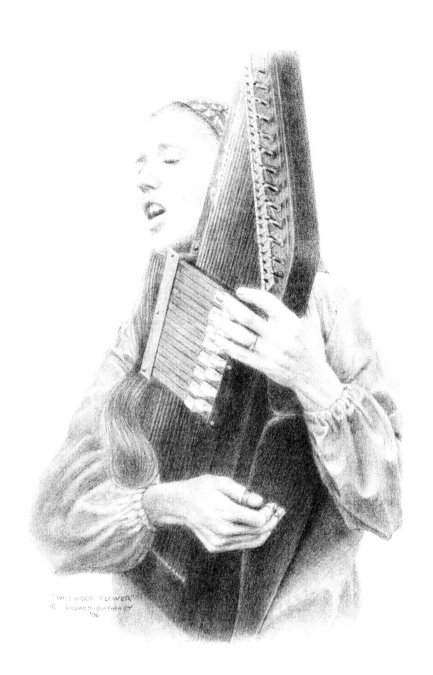

"WILDWOOD FLOWER"
© WILLARD GAYHEART
'06

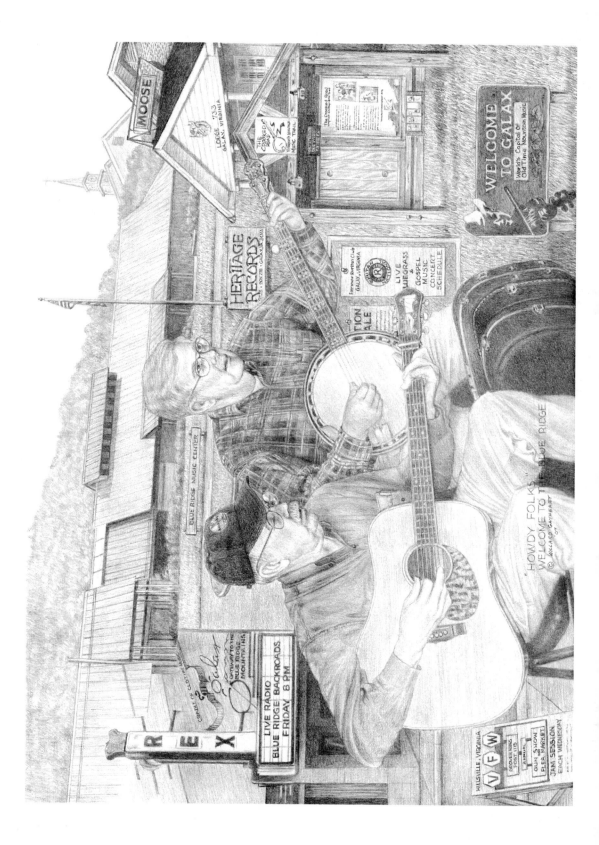

Howdy Folks
Welcome to the Blue Ridge
2007

Willard describes this drawing:

I've drawn this of myself and Bobby Patterson. We play at the Blue Ridge Music Center on the Blue Ridge Parkway near Galax every summer. On Tuesdays you'll find us there from June to October. This was the second year we'd played there and I thought probably I ought to do a drawing if folks coming along wanted to take a souvenir home with them of Bobby and me playing. I added some other notable places around Galax where you can find music, like the Moose Club or Fairview Ruritan Club or the Rex Theatre or the VFW in Hillsville, all places that have music on almost a weekly basis, especially the Rex. You'll find music there every Friday night. The drawing has done quite well. We were able to offer something of the area for people to identify.

Willard is also at the music center every Thursday during summer months with his son-in-law, Scott Freeman. Scott, Bobby, and Willard entertain people of all ages who find their way to the center off the Parkway. They come from all parts of the U.S. as well as other countries.

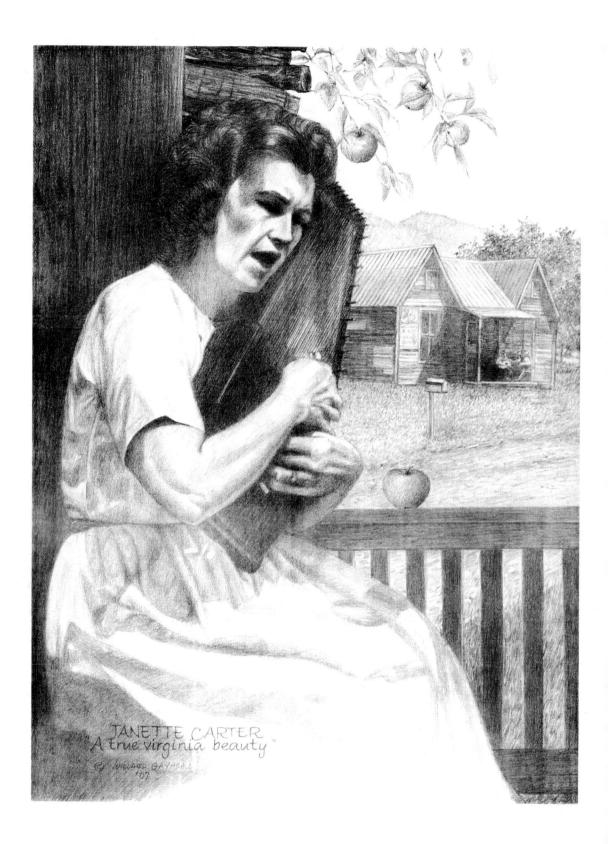

JANETTE CARTER
"A true virginia beauty"
© HOWARD GAYHEART
'07

Janette Carter
2007

"One of the most memorable people I've ever known," Willard said, is Janette Carter, daughter of Sarah and A.P. Carter. She started the Carter Fold in Hiltons, Virginia, and over 30 years later the Carter Fold continues to celebrate the life and music of her family. It is a popular venue for weekly live music. The old Carter Store is now a museum.

Janette passed away in January of 2006, but her daughter, Rita Forrester, continues Janette's dedication to keeping the Carter Family Fold, museum, and music alive. "She worked hard to make the Fold a great place to go and she performed there, often with her brother Joe."

This drawing is owned by a family in Kentucky and was done from a photograph taken of her at the Galax Old Fiddlers' Convention when she was younger.

Willard added, "I changed the background and put the store building her father built (now the museum) in the background, back in time to what it might have looked like in the 1940s. I also added a Virginia Beauty apple, synonymous with Janette, because I thought she was a true Virginia beauty in many many ways. This was a drawing I really enjoyed doing."

Joe Wilson & Friends
Virginia's National Treasure
2007

In 2007 during the summer concert series at the Blue Ridge Music Center a concert was held to honor National Heritage Award winners from Virginia. Also called National Treasures, these winners have achieved the nation's highest honor in folk and traditional arts, an honor bestowed by the National Endowment for the Arts.

The drawing features Joe Wilson in the center. He is a delightful man to talk with, and so accessible for one who is in constant demand, much like Willard Gayheart. Joe's list of accomplishments is far too long to mention here, but two out of the dozens in his bio include founding the Blue Ridge Music Center and co-founding the Crooked Road. He also spent 1976 to 2004 as director of the National Council of Traditional Arts in Washington, D.C., before leaving it all to return to the mountains of Virginia.

Joe Wilson and Willard Gayheart can't say enough nice things about each other, but Joe likes to poke fun at Willard. He offered during our conversation to try to think of something negative to say about Willard Gayheart "since no one ever does," he said, followed by, "I've known him 25–30 years, since Shep was a pup!" The only negative he could come up with was, "Willard Gayheart has too much fun, but he's a really fine guitar player and draws pretty well too!"

Clockwise from the top, the other National Treasures include Dr. Ralph Stanley, Wayne Henderson, John Jackson, Flory Jagoda, John Cephas, Janette Carter, and Jim and Jesse McReynolds.

The original drawing belongs to Joe Wilson, though he has yet to pick it up from the Front Porch Gallery.

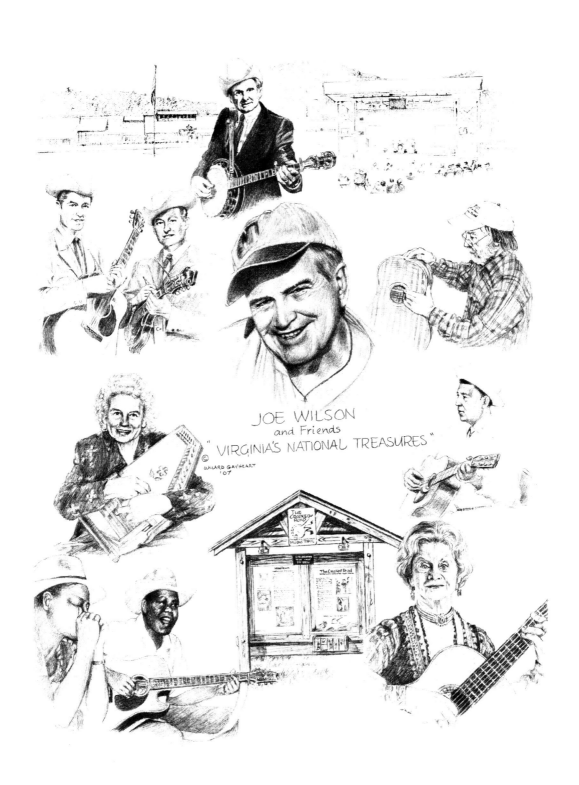

JOE WILSON
and Friends
© "VIRGINIA'S NATIONAL TREASURES"

WILLARD GAYHEART
'07

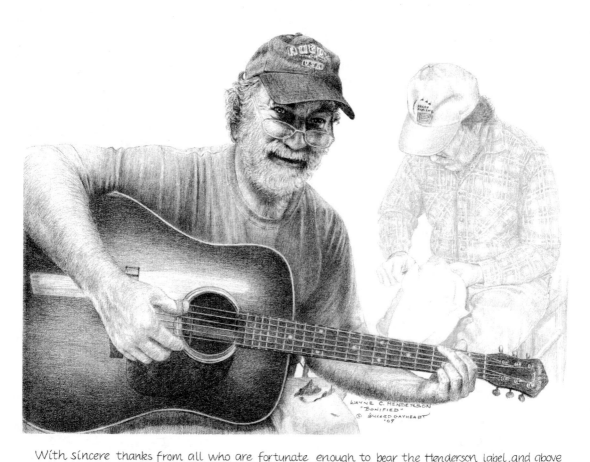

WAYNE C. HENDERSON
"BONIFIED"
© WILLARD GAYHEART
'09

With sincere thanks from all who are fortunate enough to bear the Henderson label, and above all call Wayne C. friend. This drawing of an American Original declares our pal "Bonified"

Wayne Henderson
Bonified
2007

Willard said,

*Wayne was turning 60 and I own one of his Henderson guitars
and I just wanted to do something special for him. I traded him a
drawing a few years back for a guitar and I still need to do things
for him in exchange for that guitar.*

*I did this to give to him at a little birthday party in May of
2007, and we decided to have prints made for the Wayne Hender-
son Festival because we have a lot of signatures on here—lots of
folks who own his guitars signed the drawing.*

*Every year now when I set up at the Henderson Festival the
third weekend in June, whatever I sell I donate half to the festival.
The money goes to Wayne's scholarship for young people learning
to play traditional music, one of the big things he does for his com-
munity.*

*With all the guitars Wayne builds, he finds the time to build a
new one each year for the festival and the winner of his festival gets
it.*

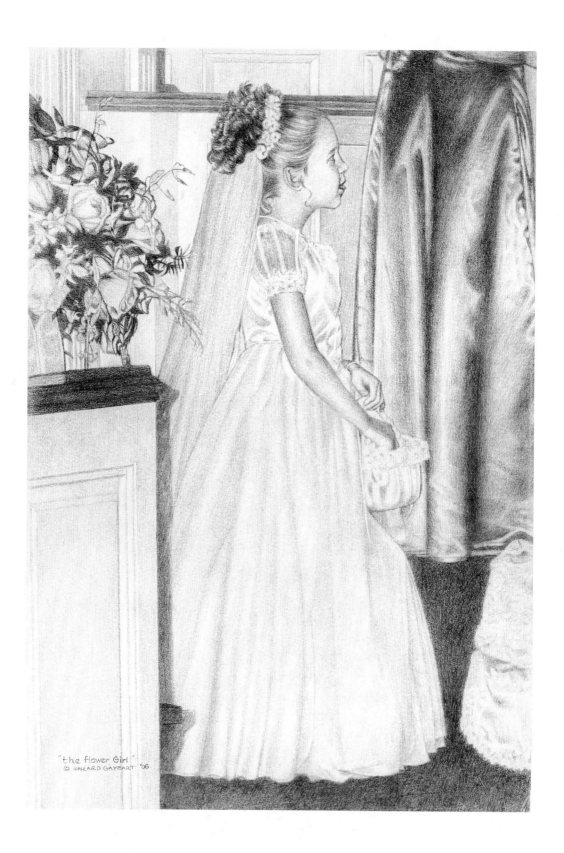

"the flower Girl"
© WILLARD GAYHART '08

Flower Girl
2008

Willard said, "My granddaughter Dori was the flower girl at a wedding in Mt. Airy, North Carolina, when she was about eight years old."

Dori's mother, Jill Gayheart Freeman, added that young Dori was very unhappy that she had to wear her hair curled and secured in a headpiece all day long leading up to the evening wedding. Immediately following the service she rushed to the dressing room, removed all the headgear and the frilly dress, and returned to the reception in her T-shirt and shorts.

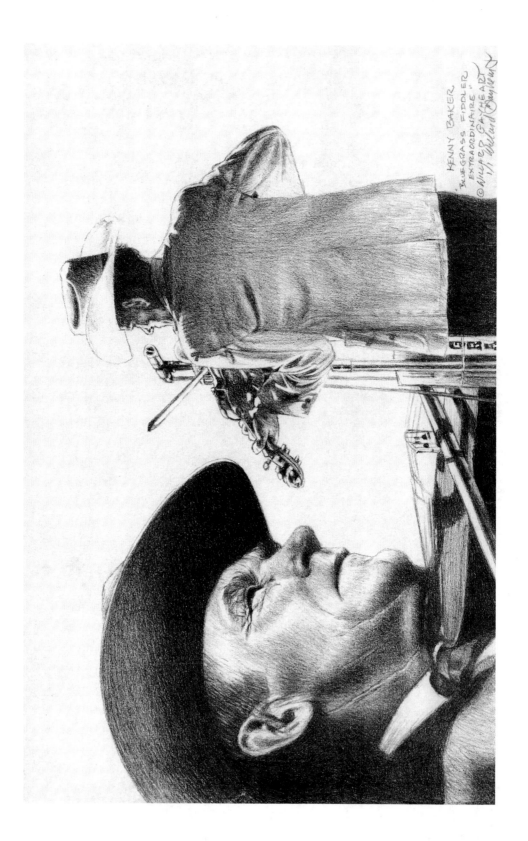

Kenny Baker
Bluegrass Fiddler Extraordinaire
2008

Kenny Baker once said, "Bluegrass is nothing but a hillbilly version of jazz." Born in 1926 in Burdine, Kentucky, he began to play the fiddle as a child and eventually played with Bill Monroe, the father of bluegrass music, also from Kentucky. Kenny remained with Monroe's Blue Grass Boys off and on for many years, sometimes having to return to coal mining or farming for financial reasons, but he always came back to the music and recorded a number of albums.

Ron Riffe and a group of friends commissioned Willard to do this drawing of Kenny Baker as a gift for a young fiddler who would come to Ron and Janet's house to jam with them. Ron said this young woman is one of the best fiddlers around, and Kenny Baker was her idol.

Prints are available at the Front Porch Gallery.

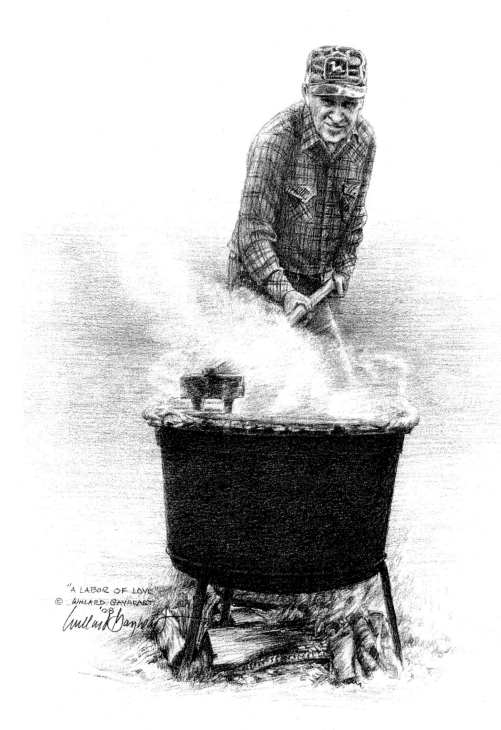

"A LABOR OF LOVE"
© WILLARD GAYHEART
'08

Labor of Love
2008

Several Saturdays before the annual Lord's Acre Sale at the end of September, Willard's church, Mt. Olivet United Methodist in Galax, will be making apple butter to sell.

Willard explained,

> *We make many gallons to sell. This is Foy Hill, a member of my church, making the apple butter in the fall of 2008. It's a time of fellowship and work and it's an all day affair to make it. Foy is a stalwart and his wife Bonnie has the recipe and is also instrumental in getting this job done. Foy and others stir the apples.*
>
> *I thought it appropriate to do this one and I did it for the Lord's Acre sale at Felts Park in Galax and gave the original to my church.*

Lord's Acre sales are a fall tradition where church families come together on a Saturday in September and sell many items from crafts to vegetables, flowers, and homemade products such as apple butter. Proceeds go to support ministries and missions.

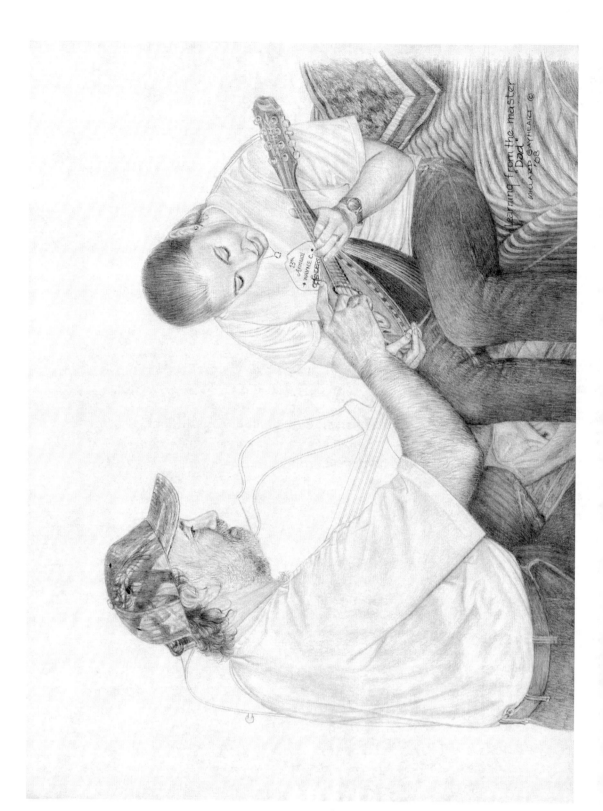

Learning from the Master
"Dad"
2008

Jayne Henderson, daughter of Wayne Henderson, took a break from pursuing a career in environmental law to build guitars with her father, "learning from the master."

Jayne writes:

> *I love this drawing because there are so few instances that I can claim as something between just me and my dad, and as far as depicting our relationship in general, this definitely hits the nail on the head. My dad has always been willing to help and instruct anyone with music or building instruments and he has patience for each person, but I never understood that awe and appreciation he gets from people until I started learning from him too. He has taught me chords on the mandolin, and is now teaching me how to build guitars with the same patience and care. He is a kind person who will humbly and thoughtfully pass his knowledge on, and I am so grateful that Willard drew a picture immortalizing that for me especially. I know my dad is well known to many people to be a great teacher, but it is important to me that I get to be involved in this aspect of his life, as it is obviously a large one.*

Willard did this drawing from a photo. There are no prints and the original hangs in Wayne's home in Rugby.

Willard was in Wayne's shop on a Sunday afternoon in February 2013 when Wayne began crafting Willard a new guitar. Willard picked out the wood for the back and Wayne glued it in the middle down the center, creating a "book match." Wayne told him that the maple wood is split off the same piece so that after it is planed and glued, the grain from both pieces match. Willard recounted, "Wayne is always working and I got to watch him do that. He just built a guitar for a fellow in Canada and it just beats anything I ever saw, beautiful, modeled from an old Gibson from the 1930s with celluloid inlay up and down the fret board. It's a rare thing from a piece of wood with a sunburst reddish brown finish, one of the most beautiful guitars I've ever seen in my life. And I played one of Jayne's guitars and it was a fine guitar."

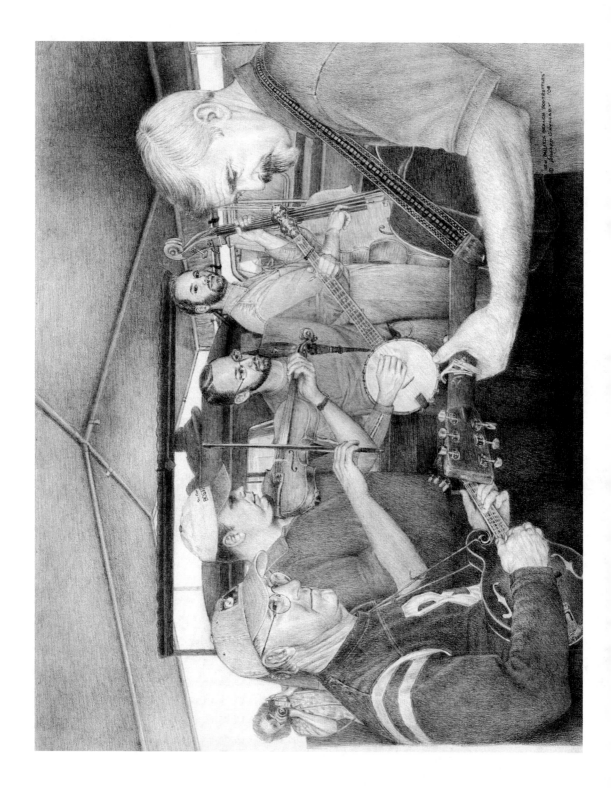

New Ballads Branch Bogtrotters
2008

Josh Ellis, banjo player for the New Ballads Branch Bogtrotters, is the owner of this drawing, commissioned by his fiancée as a gift for him. The award-winning old-time string band is named for a 1930s era group called the Bogtrotters.

The New Ballads Branch Bogtrotters have performed in venues from the Kennedy Center in Washington, D.C., to the Carter Fold in Hiltons, Virginia, and many other places throughout the region. Josh said they toured in England in 2012, but each member still must keep their day jobs.

Willard said the band is noted for playing the old traditional music and mountain dancers love to clog and flatfoot to the tunes.

Sweet Bunch of Daisies
2008

Willard says, "This is my granddaughter Sarah, drawn from a photograph when she was about two years old. She's now a student in her teens who loves to draw and paint and takes art lessons on weekends. She's a very sweet young lady."

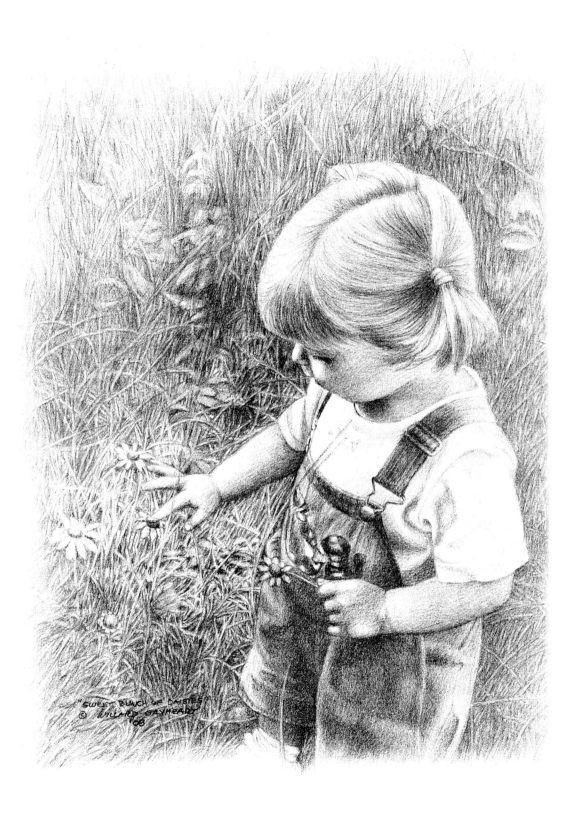

"SWEET BUNCH OF DAISIES"
© Willard Gayheart
'08

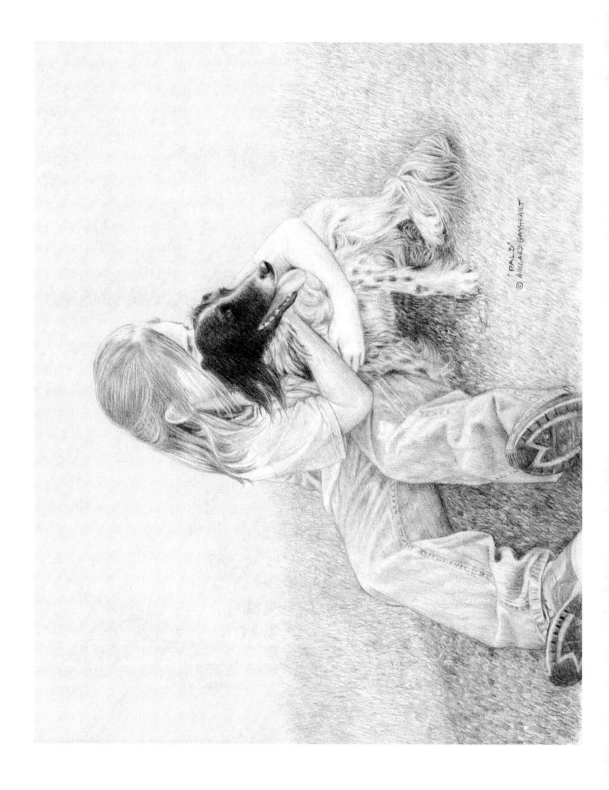

"PALS"
© WILLARD GAYHEART

Pals
2009

This drawing features Dori, Willard's granddaughter, and her beloved Maggie, a rescue dog. Dori's father, Scott Freeman, rescued the dog from a sad life and she brought a lot of happiness to the family before her death some nine years later.

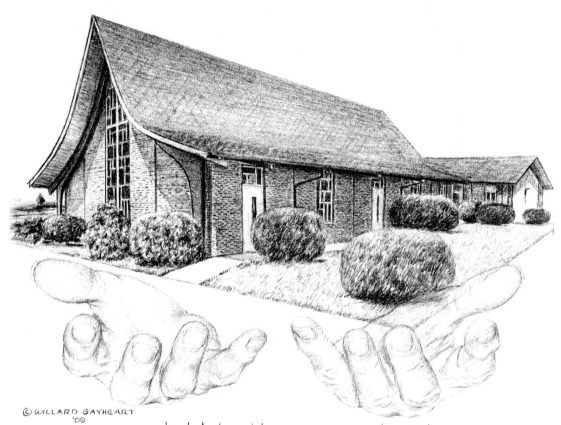

© WILLARD GAYHEART
'09

upheld by the unseen hand

Upheld by the Unseen Hand
2009

This drawing was created for a fundraiser for Mount Olivet Methodist Church and the Methodist Men. Willard and his late wife Pat have been longtime members of the church.

Fellow church member David Williams suggested the idea of using hands to symbolize God as the undergirding for the church. Willard used a model of his own hands in the drawing and says, "I think this is very significant in how God undergirds and takes care of His own and upholds us."

Several prints were made and framed to sell and T-shirts featuring the drawing were also sold.

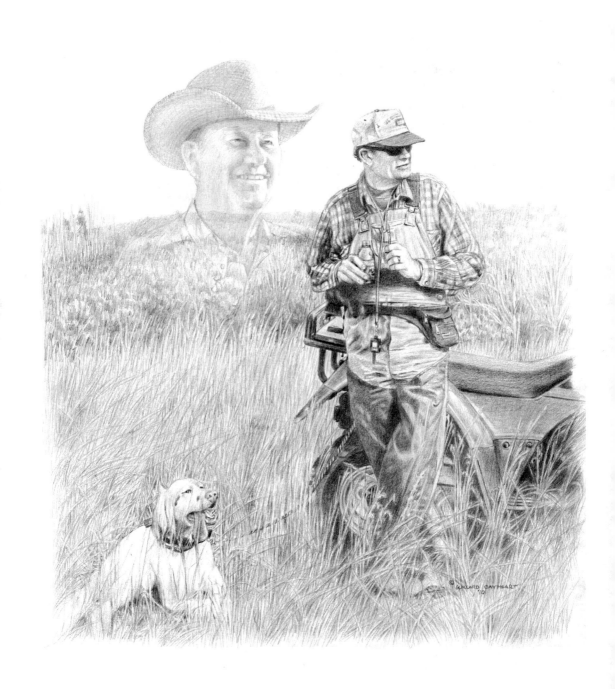

Andy Dudley & Spike
2010

Andy and Lynn Dudley live on a farm in the Leatherwood Community near Martinsville, Virginia, where Andy has enjoyed hunting over the years. With a "real touch," according to Lynn, he's trained several dogs over the years and Spike, featured in this drawing, was a special friend to Andy. The photo Willard used was taken during break time on a day of training.

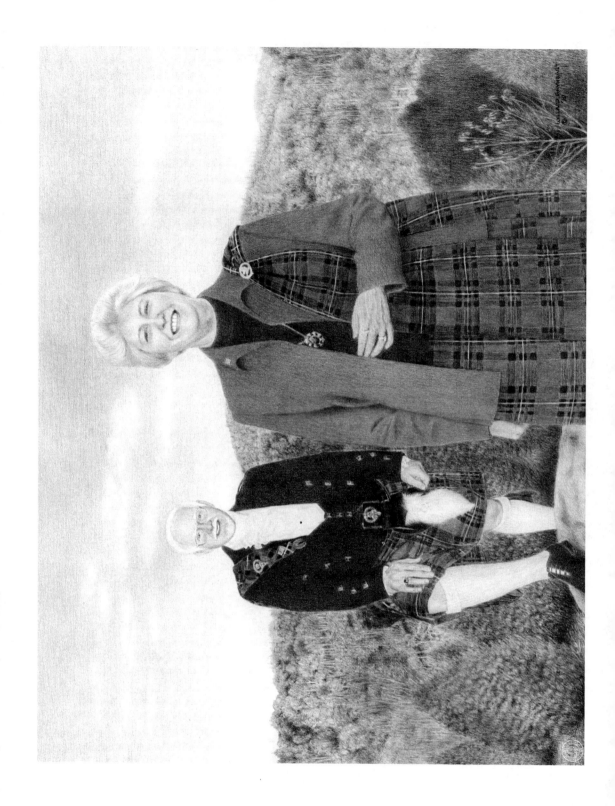

Dr. Grace Toney Edwards
Dr. John C. Nemeth
2010

In the early '90s Willard participated in an Appalkids event at Pulaski County High School. The Appalkids were a student group of singers, dancers, actors, and musicians who promoted Appalachian culture. Willard met Grace Toney Edwards at one of those events. Willard recalled,

> *Dr. Edwards asked me to be part of parents' weekend and Appalachian Awareness festivities at Radford University and I've been doing it ever since. Through the years every time I got around Grace I was encouraged, and she has been such a factor in so many things I've done, though she probably doesn't know it. She has been an inspiration to me. All those years going to the Appalachian Awareness Day, the number of people I've met through that event, being able to play music there, all that was such an honor for me. And then to get to be a part of Grace's retirement, just to be there, to meet her family and see how she grew up. She is just a great example to everybody, so encouraging and so positive.*

Radford's Appalachian Studies program started in 1981. Grace was hired for the program and founded the Appalachian Regional Studies Center in 1994. She was director of the center until her retirement in 2010.

Grace's husband, John Nemeth, said, "The first time I saw a Gayheart drawing, the man on the porch, that she gave me, I knew one day I would commission Willard to do her portrait. A renaissance man, an artist of Appalachia depicting another Appalachian treasure."

Grace's response to the drawing:

> *The portrait was an absolutely total surprise to me! When it was unveiled at my retirement party I was flabbergasted. I felt moved and honored that Willard had spent so much time and effort to create this large and colorful portrait of John and me. I continue to marvel at the detail Willard put into the drawing. Even now, I'm apt to find something new each time I take a close look. Willard Gayheart's talent is simply amazing.*

The Homecoming
2010

This is one of four Gayheart drawings owned by members of the Larry and Susan Lindsey family. Others include *James Lindsey, Blueridge Masters* (2004), *James Lindsey, Musician, Sportsman, Photographer Salesman* (1979), and *A Mother's Touch* (2010).

Larry and Susan's son, Captain Brandon Lindsey, was serving his second tour of duty in Iraq when his son, Grayson James Lindsey, was born on May 29, 2010. With Skype technology Brandon was able to witness the birth and on August 25, 2010, he safely returned home to Virginia.

At a reception for the troops Larry Lindsey took a photo of Brandon's homecoming and first meeting with his son Grayson while Brandon's wife Georgia looked on.

Larry and Susan gave the drawing to Brandon and Georgia for Christmas in 2010.

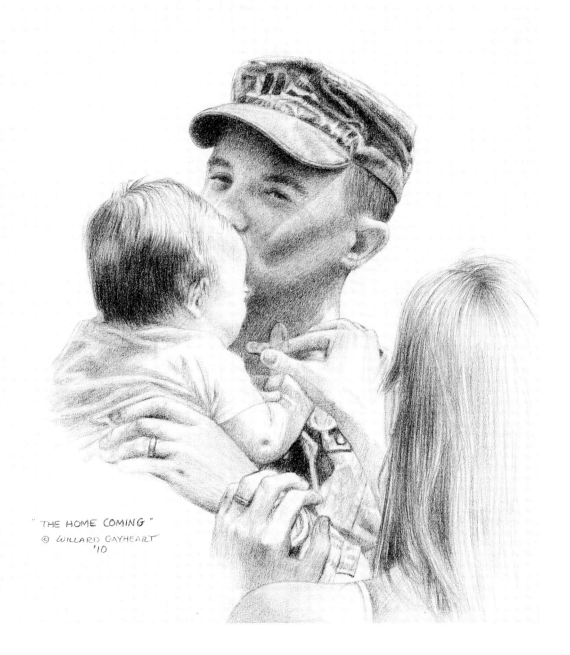

"THE HOME COMING"
© WILLARD GAYHEART
'10

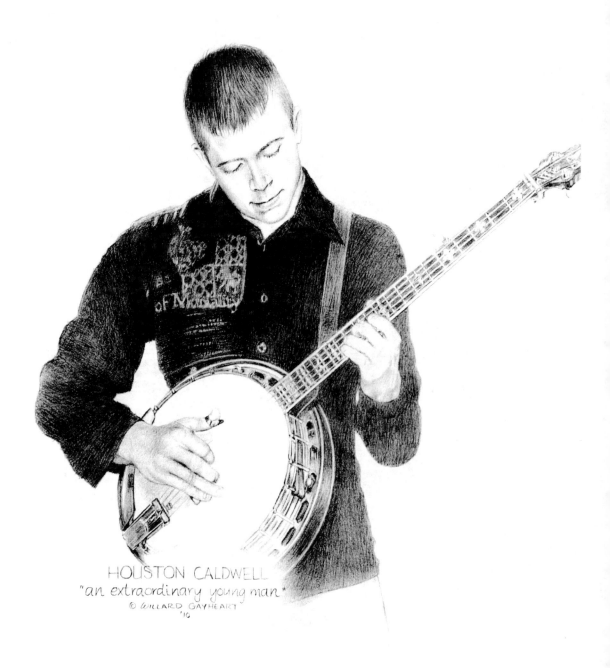

HOUSTON CALDWELL
"an extraordinary young man"
© WILLARD GAYHEART
'10

Houston Caldwell
An Extraordinary Young Man
2010

According to Willard,

> *Houston was a young prodigy, played the banjo since he was very young, age 10 or 11. He was an accomplished young musician who got a lot of attention because of his music and also because of his good character. He graduated high school early to get started on his military interest, entered the United States Army Reserve, completed his basic training, and his plan was to come home, serve in the Army Reserves, and pursue his education, but remain in Galax. He loved this community. Houston wrote letters home about how he loved and missed the music and wanted to stay around and contribute to the music of the region.*
>
> *He was a member of the Galax Volunteer Fire Department, a very conscientious public-minded young man, always willing to volunteer in his community.*

Tragically, Houston died in a motorcycle accident on April 30, 2010. He was only 18. Much has been written about this young man and his music, his presence and skill at traditional music events all over the southeastern United States. He touched many lives of all ages. Some say nearly 3,000 people showed up to pay their respect to Houston and that the streets of Galax were lined with mourners.

The first weekend in May, HoustonFest is held in memory of this young man and some proceeds go to a new Houston Caldwell Scholarship to encourage young traditional musicians who need aid for instruction, camps or workshops. Willard remarked, "We hope this will continue to be a success because he was such an extraordinary young man and his family is determined to use his character as a kind of role model to influence others."

The drawing was done for the Fiddlers Convention in Sparta, North Carolina, and presented to the family the summer after Houston died. They own the original, but prints are available at HoustonFest in Galax at Felts Park.

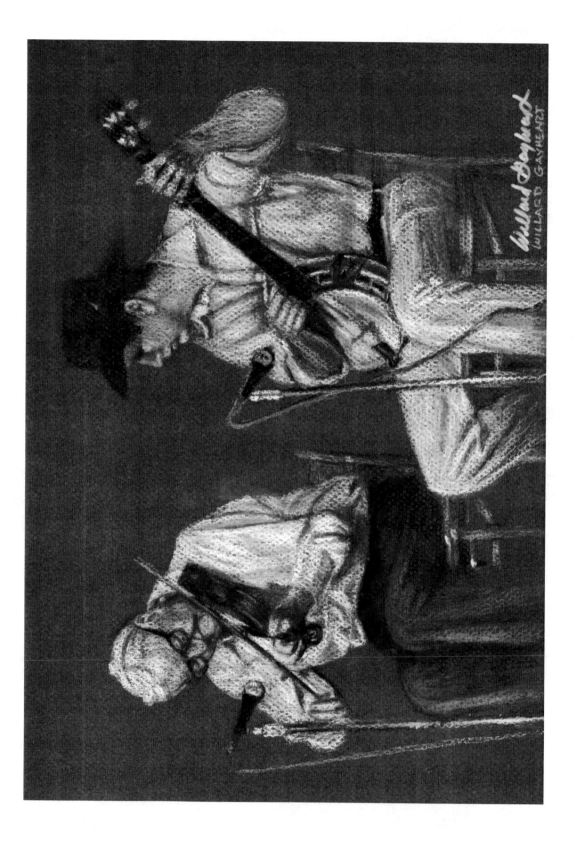

Jarrell Duet
2010

Tommy Jarrell is a name and face found in several drawings by Willard, as early as 1984 and as recently as this one in 2010. Jarrell was a fiddler from Mount Airy, North Carolina, and a winner of the National Heritage Fellowship award from the National Endowment for the Arts.

Willard says Tommy was the most famous of old-time musicians in the region. He played fiddle and banjo, but worked days for the North Carolina State Highway Department. Following his retirement he played music at a lot of locations including Wolftrap and the Smithsonian Folklife Festival.

Young musicians discovered Jarrell and appreciated his knowledge of the old fiddle and banjo tunes. He opened his home up and they flocked to him to learn.

Paul Brown is featured in this drawing with Tommy. Paul is a musician from Mount Airy who now works for National Public Radio. He can be heard each morning broadcasting news from Washington, D.C.

The Tommy Jarrell Festival is held each March at the Andy Griffith Theatre in Mount Airy.

Willard says this drawing was done as an experiment. He said he "just wanted to try something different." It was drawn on dark, textured paper, which makes reproduction difficult and explains the "dotty" appearance.

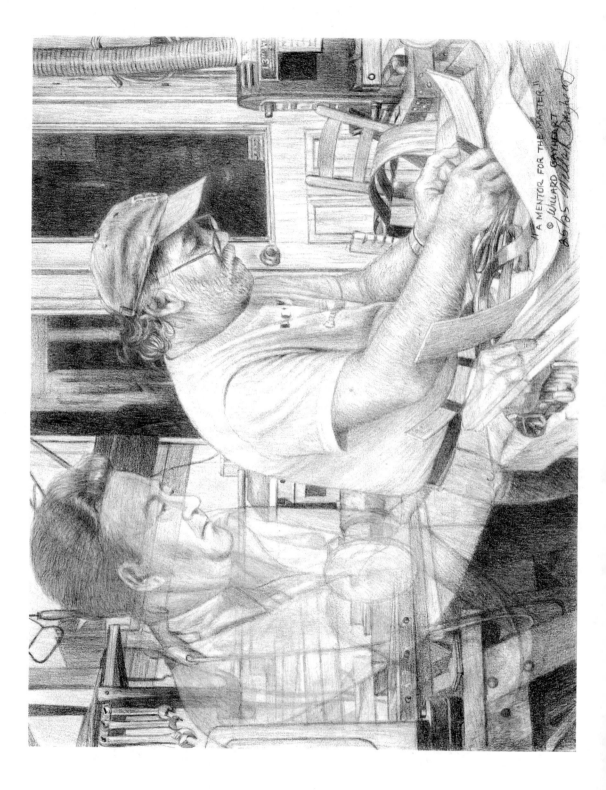

"A MENTOR FOR THE MASTER"
© WILLARD GAYHEART
8/6/05 [signature]

A Mentor for the Master
2010

Albert Hash was a musician, instrument builder, and a competent machinist who crafted tools to aid in the building of instruments. He was born in Rugby, Virginia, also the hometown of renowned musician and guitar builder Wayne Henderson.

It is reported that Hash built his first fiddle at age 10 during the Depression. He went on to mentor Wayne Henderson in his guitar building business, created tools for Wayne to use, and they enjoyed playing music together until Albert's death in 1983.

Willard has drawn a kind of spiritual figure of Albert looking over the shoulder of Wayne Henderson in his shop in Rugby.

Willard said, "Albert is sorely missed."

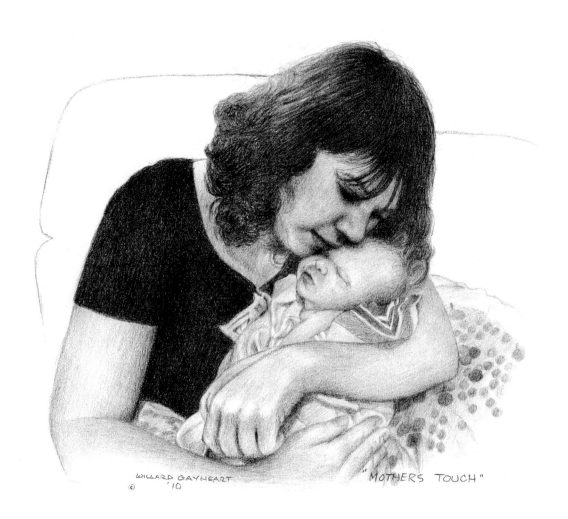

WILLARD GAYHEART
©
'10

"MOTHERS TOUCH"

A Mother's Touch
2010

This drawing was done from a photograph taken by Larry Lindsey of his and Susan's daughter, Whitney Hodges, holding their granddaughter, Savannah Lindsey Hodges.

An unstaged moment, the photograph was taken in a pediatric intensive care unit where the young mother waited for the six-day-old child to be taken into open-heart surgery.

Larry and Susan gave the drawing to Whitney and Jake Hodges during Christmas 2010.

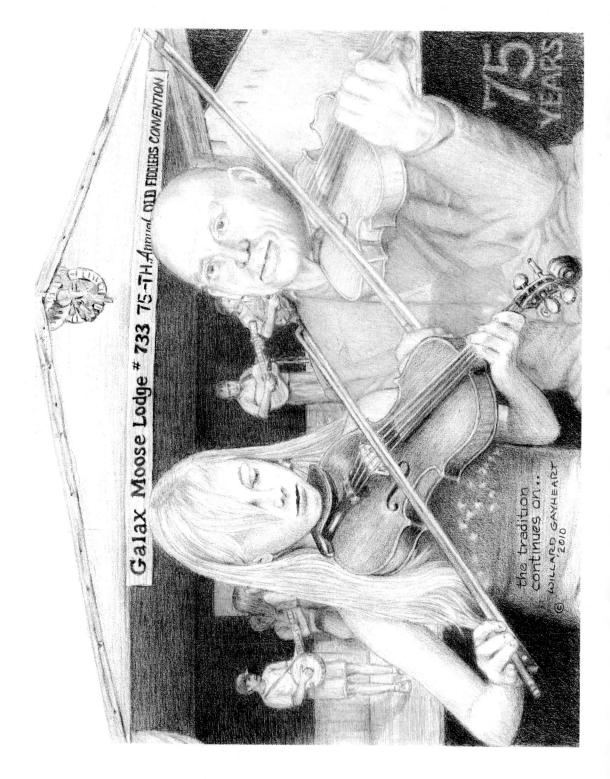

Galax Moose Lodge # 733 75-TH. *Annual* OLD FIDDLERS CONVENTION

75 YEARS

the tradition
continues on...

© WILLARD GAYHEART
2010

The Tradition Continues On
2010

To commemorate the 75th anniversary of the Galax Old Fiddlers' Convention Willard created this drawing of one of the youngest contestants in 2010, Kali Jo Taylor, and one of the earliest contestants from 1933, Eck Dunford.

Uncle Eck Dunford was a musician from Carroll County who made several recordings with Victor Records in the 1920s.

Kali Jo is a young fiddler and a music student of Scott Freeman, Willard's son-in-law.

Seventy-five prints were made to celebrate the 75th anniversary.

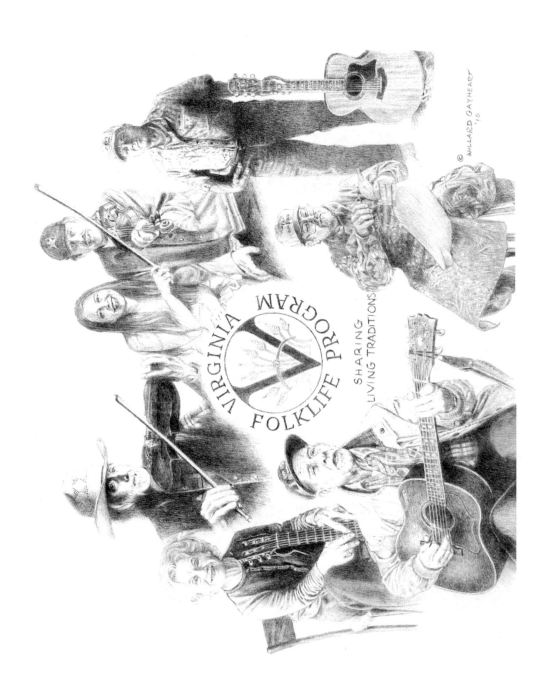

VIRGINIA FOLKLIFE PROGRAM

SHARING LIVING TRADITIONS

© WILLARD GAYHEART '10

Virginia Folklife Program
Sharing Living Traditions
2010

Jon Lohman is Virginia's folklorist and director of the Virginia Folklife Program in Charlottesville, Virginia, a job that takes Jon all over the state pursuing, preserving and promoting folk traditions. Jon is also a musician and author. His book, *In Good Keeping*, was published in 2007 and tells of the first five years of one of Jon's programs through Virginia Folklife, the Folklife Apprenticeship Program.

The Folklife Apprenticeship Program pairs an experienced master artist with a young apprentice, eight pairs a year, working together one-on-one for nine months. One example is Wayne Henderson, well-known guitarist and luthier from Rugby, Virginia who mentored his daughter Jayne, teaching her how to carry on his high level of expertise in making instruments.

Featured in this drawing are, starting far left and going clockwise: Flory Jagoda, Sephardic Jewish ballad singer; Buddy Pendleton, bluegrass fiddler; Martha and Thornton Spencer, old-time musicians; John Cephas, Piedmont blues artist; Grayson Chesser, decoy carver; and Spencer Moore, Appalachian songster.

Jon commissioned Willard to do this drawing and make prints to sell as a fundraiser for the Master & Apprentice Program.

The Dinner Bell
2011

Ron Riffe said the dinner bell was just a part of his everyday life growing up. Whether he and other family members were working in the corn, hay, or back in the woods, his mother would ring the bell about 30 minutes before she was ready to put the midday meal on the table. She did not like her food to get cold before everyone came in from the fields.

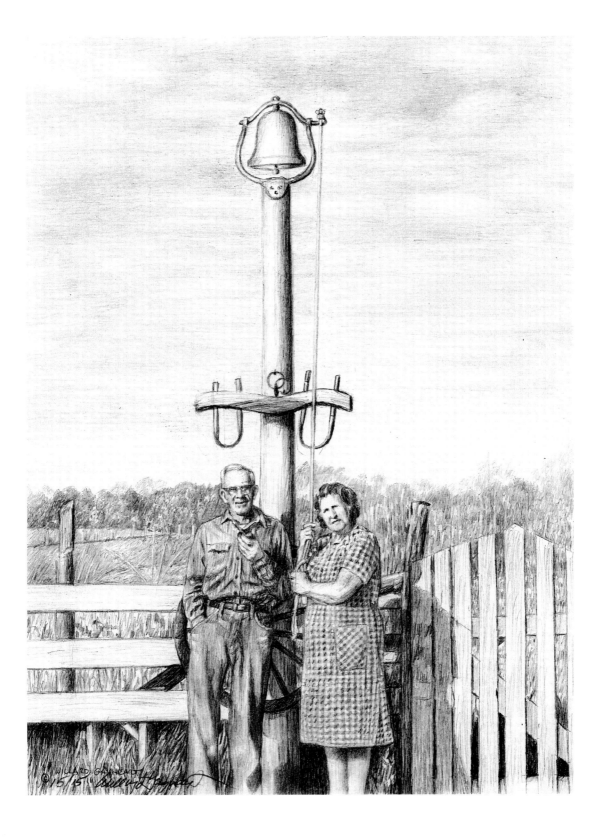

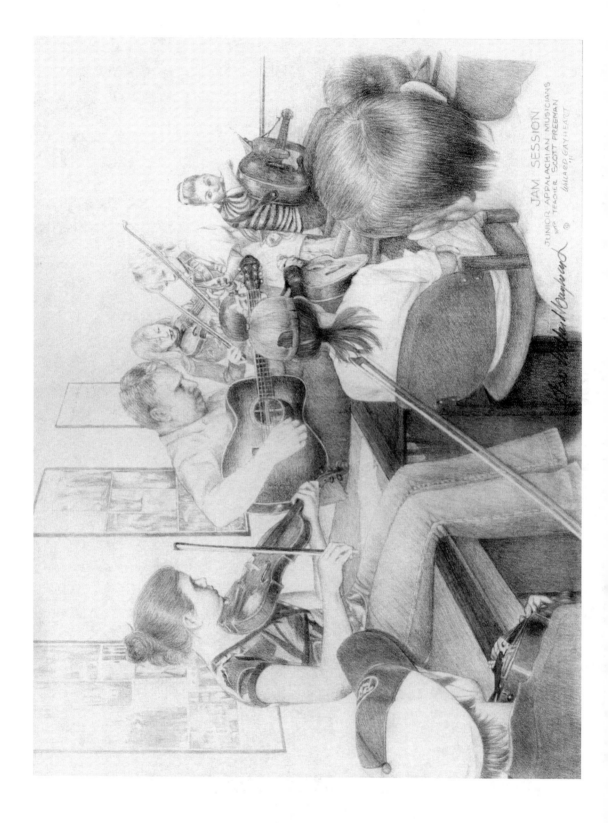

JAM SESSION
JUNIOR APPALACHIAN MUSICIANS
WITH TEACHER SCOTT FREEMAN
© WILLARD GAYHEART

Jam Session
2011

Scott Freeman, Willard's son-in-law, is featured here working with Junior Appalachian Musicians, or "Jam Kids," at the Blue Ridge Music Center.

These young people participate in an after-school program intended to introduce them to traditional music and dance, and they learn from musicians in their communities. Formed by Helen White, well-known musician and advocate for youth, "Jam Kids" has become a sought-after program throughout southern Appalachia and serves over 20 locations in North Carolina, South Carolina and Virginia.

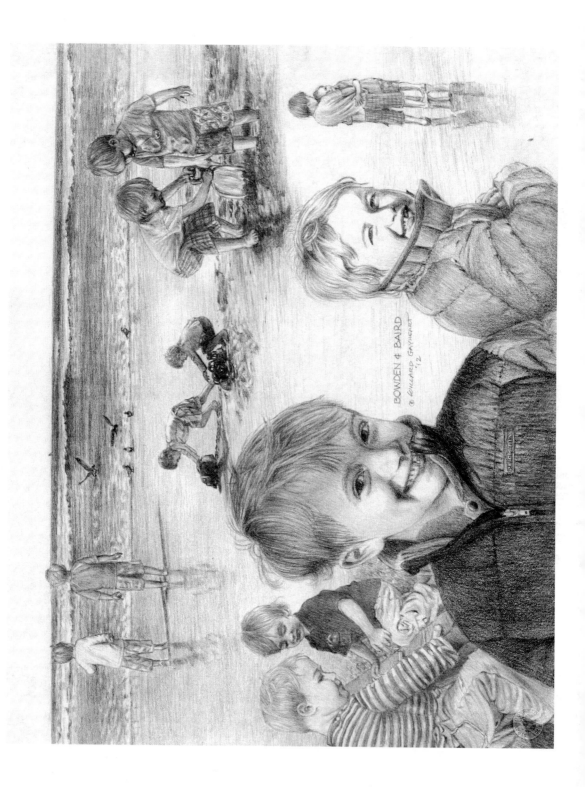

Bowden & Baird Eley
2012

Says Donia: I have known Willard Gayheart since about 1990 when my family acquired our first Gayheart drawing, *A Turn to the Light*, at the Virginia Highlands Festival in Abingdon, Virginia. Our Gayheart collection has grown, but this is my new favorite and our only original.

Bowden and Baird are my grandsons, now ages six and three. They live in southern California near the beach and have spent many hours of their young lives digging in the sand, chasing seagulls, flying kites, watching the waves, the surfers, sailboats in the distance, celebrating special occasions, always with the big Ferris wheel at the Santa Monica Pier in the distance.

I dropped off a stack of photographs of the boys at Willard's Front Porch Gallery and asked him to "take a look at these and draw something, whatever you see." He did, capturing their favorite activities and their faces.

This drawing was a gift to my son Hunter and his wife Lael for Christmas 2012.

Lael Eley wrote,

> *I was struck by the degree of accuracy of the likenesses—both in the authenticity of the forms replicated and the emotions captured. It's remarkable. The montage layout of the images has a natural flow and a nice foreground and background effect, but mostly I notice how accurately he captures the boys in that particular moment in time—even better than the photographs did, because his drawings somehow crystallize the moment by draining it of all color, extraneous detail and background clutter. It's a strange tension between realism and photography—his "realistic" drawings look more real than photographs by capturing detail so accurately yet leaving out so much of what's really there—primarily color! That is, I think, the real testament to his art—he captures the essence of what is there with impeccable, amazing detail—hard to believe drawn by hand—and yet, it is drawn by hand and as much information is left out as is captured yet it feels hyper-realistic and impeccably distilled.*

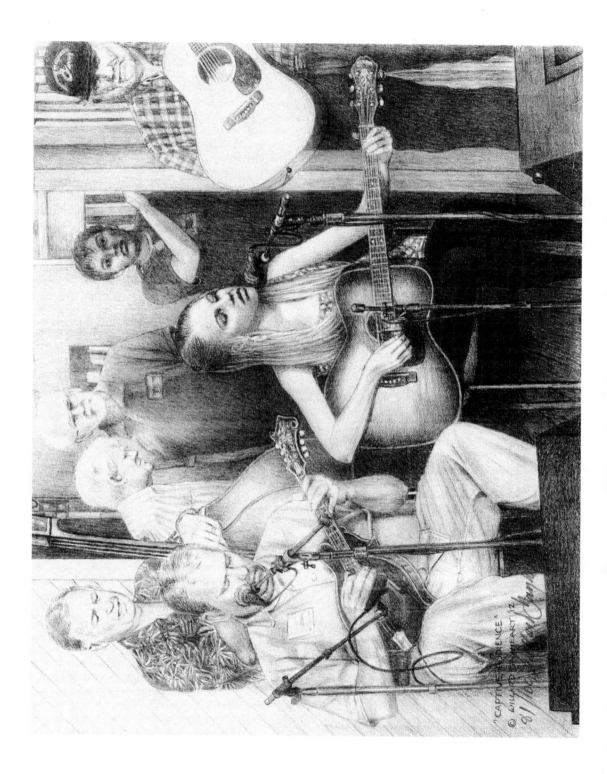

Captive Audience
2012

In this drawing that captures a poignant moment, Willard's grand-daughter Dori is featured singing "The Long Journey," written by Doc and Rosa Lee Watson. Dori performed the song at the Blue Ridge Music Center on Friday night, June 17, 2011, her first time performing in Doc's presence.

Doc, scheduled to perform the next day at the Wayne Henderson Festival, was at the Friday night event. He stood listening to Dori just as he is shown in this drawing (back row, second from left), wiping tears, and he hugged and thanked the young musician as she finished the song. Dori also performed at the Henderson Festival the following day.

Playing with Dori is her father, Scott Freeman. Herb Key, a bass and guitar player from Wilkesboro, North Carolina, who also helps Wayne Henderson in his shop, doing guitar repair work, is standing at the far left. Charles Welch, a good friend of Doc's, is at the center, and Lucas White (second from right) was there. A student at Middle Tennessee State University, Lucas is originally from Texas, and is a great guitarist. Wayne Henderson listens at the far right.

Willard did this drawing for his own enjoyment, but the original sold to a man from New York who attends the annual Wayne Henderson Festival held the third Saturday in June at Grayson Highlands State Park in Mouth of Wilson, Virginia.

Jane Gurley
2012

Jane Gurley felt an immediate kinship with the subjects of Willard Gayheart's art when she met him about 17 years ago at the Museum of Appalachia in Clinton, Tennessee. Willard's art was set up at the museum's annual three-day Fall Homecoming, a time to celebrate Appalachian music, crafts, artisans, and food.

Jane's Scots-Irish ancestors came to this country in the late 1600s to early 1700s, and Jane said she was awed by Willard's ability to capture "the spirit of the people" in his drawings. Willard's drawings reminded her of her fiercely independent farming family, and she saw their faces in his drawings as well as familiar faces like Ray Hicks who continued to sing the old songs and tell the old stories of Appalachia. Ray was from Watauga County, North Carolina, and is sometimes called the father of Appalachian storytelling. Willard's drawing of him (*Study of a Storyteller*, featured on page 124 of the first book) is displayed in many homes and offices across the country, and as far away as the School of Scottish Studies at Edinburgh University in Edinburgh, Scotland. In 2000 Jane took her fourth grade class to spend a day with Ray, his wife Rosa, and several of his cousins at his farm. He regaled them with his songs and tales, a walk through the woods to search out ginseng and galax leaves, and he pointed out plants and trees, explaining how they were used to make medicines. Each child left with a birch tree whistle carved by Ray and his cousin Orville.

Following the devastating death of her husband and the end of their years together enjoying mountain music, Jane decided to learn to play the autoharp. The instrument held special meaning to her after she learned that her grandparents met at a "barn play party," a fun gathering at the end of a hard day of work picking cotton. That's the night, in about 1913, that Selma Jane Price met autoharp player and singer Clark Harrill. The autoharp has brought Jane great joy. She asked Willard to do this drawing featuring her and two fiddlers, Susan Grimley and Patty Collins, two women who have encouraged Jane and welcomed her into their biweekly jam sessions.

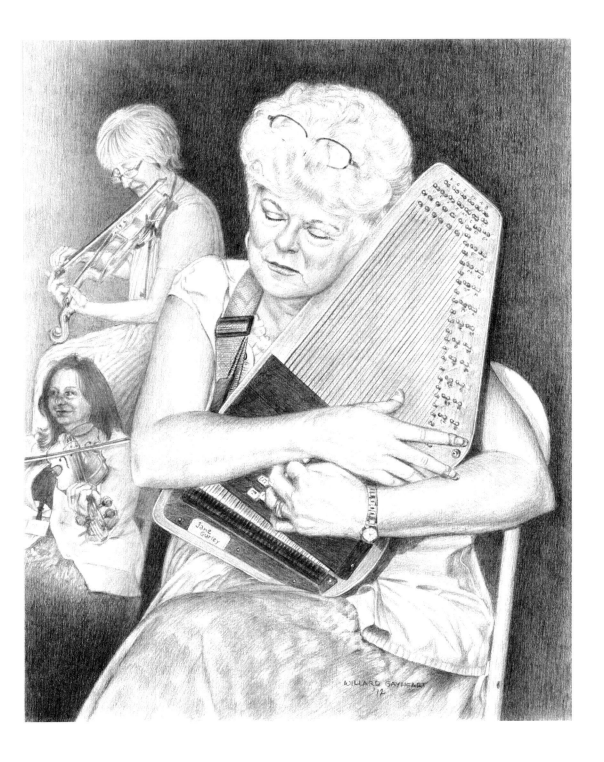

WILLARD GAYHEART
'12

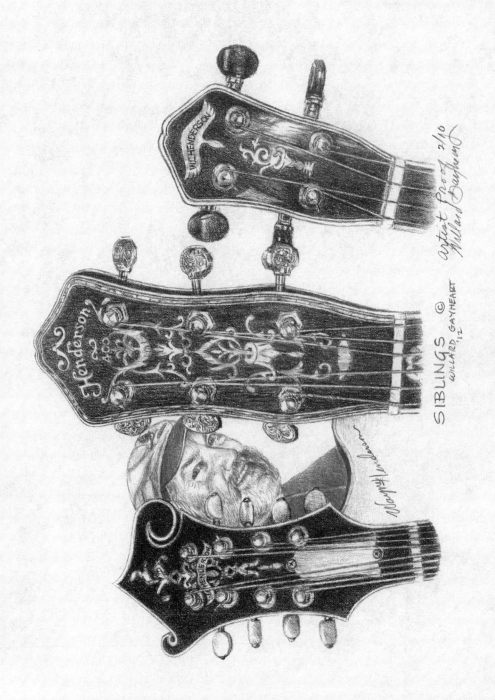

SIBLINGS ©
WILLARD GAYHEART
'12

artist proof 2/10
Willard Gayheart

Siblings
2012

This drawing was done at the request of Willard's son-in-law, Scott Freeman, and features the peg heads of three instruments Wayne Henderson built.

On the left is Scott Freeman's Henderson-made mandolin. The center instrument is Wayne Henderson's personal guitar, the 400th guitar Wayne built, and on the right is a Henderson ukulele.

To balance out the drawing Willard drew a smiling Henderson peeking from behind his instruments and had him sign the original.

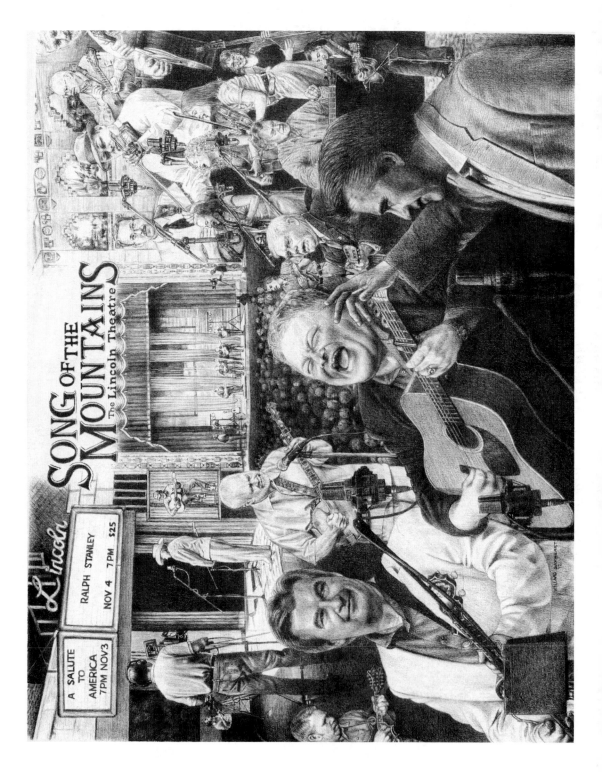

Song of the Mountains
2012

The Appalachian Spirit Gallery in Marion, Virginia, was the place to be on Saturday afternoon June 30, 2012. Willard Gayheart's drawing to benefit *Song of the Mountains* was unveiled to the oohs and aahs of supporters of the popular television program who had gathered for a first glimpse of the large drawing.

Song of the Mountains, coordinated and hosted by Tim White, celebrates old time, Celtic, bluegrass, and Americana music. The television show is filmed live at concerts held monthly at the historic Lincoln Theatre in Marion, and is distributed to PBS affiliates throughout the country. A calendar of upcoming shows can be found at songofthemountains.org.

Tim White, like Willard Gayheart, is multi-talented and was the most excited to see the unveiling of Willard's creation. Tim remarked: "It's amazing how he captures the essence of our music." Tim, earlier in the year, talked with Willard about the ongoing financial struggle to keep *Song of the Mountains* in production. Willard responded in the best way he knew with an offer to create a drawing with prints to be sold, proceeds going to support the program. A total of 450 prints were made: 100 artist proofs for $100 each, and the remainder selling for $35 each.

Willard credits Tim White with unselfish devotion to keeping traditional music alive. In addition to producing *Song of the Mountains* and being a musician and recording artist, Tim hosts a syndicated music radio show, has been the frontman for several bands, and is credited with painting the 30 × 100 foot mural on State Street in Bristol that brought the music back. The mural pays tribute to the Bristol Sessions of 1927.

Following the unveiling of Willard's *Song of the Mountains*, Tim, Willard, and others joined the crowd gathered across the street at the Lincoln Theatre where Willard took to the stage to share his other talents involving song writing, vocals, and guitar.

The drawing is a beautiful tribute to *Song of the Mountains*, but also to the beautiful Lincoln Theatre. Featured in the drawing are Wayne Henderson, Dr. Ralph Stanley, Tim White, Willard Gayheart, New Ballads Branch Bogtrotters, Redhead Express, Sandy Mason, Tom T. Hall, Tim Laughlin, Doc Watson, Edwin Lacy, Murphy White, Mack Puckett, and Scott Freeman.

INDEX